an American Souvenir

BOOKS BY ERIC SLOANE

A Reverence for Wood
A Sound of Bells
A Museum of Early American Tools
ABC Book of Early Americana
American Barns and Covered Bridges
American Yesterday
Book of Storms
Diary of an Early American Boy: Noah Blake—1805
Eric Sloane's Almanac
Folklore of American Weather
Clouds, Air, and Wind
Skies and the Artist
Look at the Sky
Our Vanishing Landscape
Return to Taos: A Sketchbook of Roadside Americana
The Seasons of America Past
An Age of Barns
Don't
The Cracker Barrel
Mr. Daniels and the Grange (with Edward Anthony)
The Second Barrel
I Remember America
Legacy
Spirits of '76
Little Red Schoolhouse
Once Upon a Time

EIGHTY
an American Souvenir

by Eric Sloane

Dodd, Mead & Company • New York

19325

No part of this book may be reproduced in any form
without permission in writing from the publisher.
Published by Dodd, Mead & Company, Inc.
79 Madison Avenue, New York, N.Y. 10016
Distributed in Canada by
McClelland and Stewart Limited, Toronto
First Edition
Printed in Verona, Italy by *Editor*

Bound in Vicenza, Italy by *Olivotto*

Typesetting by Creative Graphics, Inc.

Color separations by Sterling Regal

Library of Congress Cataloging in Publication Data

Sloane, Eric.
 Eighty, an American souvenir.

 1. Sloane, Eric. 2. Painters—United States—
Biography. I. Title: II. 80, an American souvenir.
ND237.S58A2 1985 759.13 [B] 84-18678
ISBN 0-396-08569-5

ISBN 0-396-08641-1 (Deluxe Edition)

THE ARTIST'S EXISTENCE IS A MOSAIC OF
MEMORIES: HE HIMSELF LIVES IN HOPE OF
BECOMING A MEMORY. I DEDICATE THIS
WORK TO ALL THOSE WHO TOLERATED ME,
ENCOURAGED ME TO WRITE AND PAINT,
AND AFFORDED ME EIGHTY YEARS OF COM-
FORT, UNDERSTANDING, AND A RICHER
AWARENESS OF LIFE.

Eric Sloane

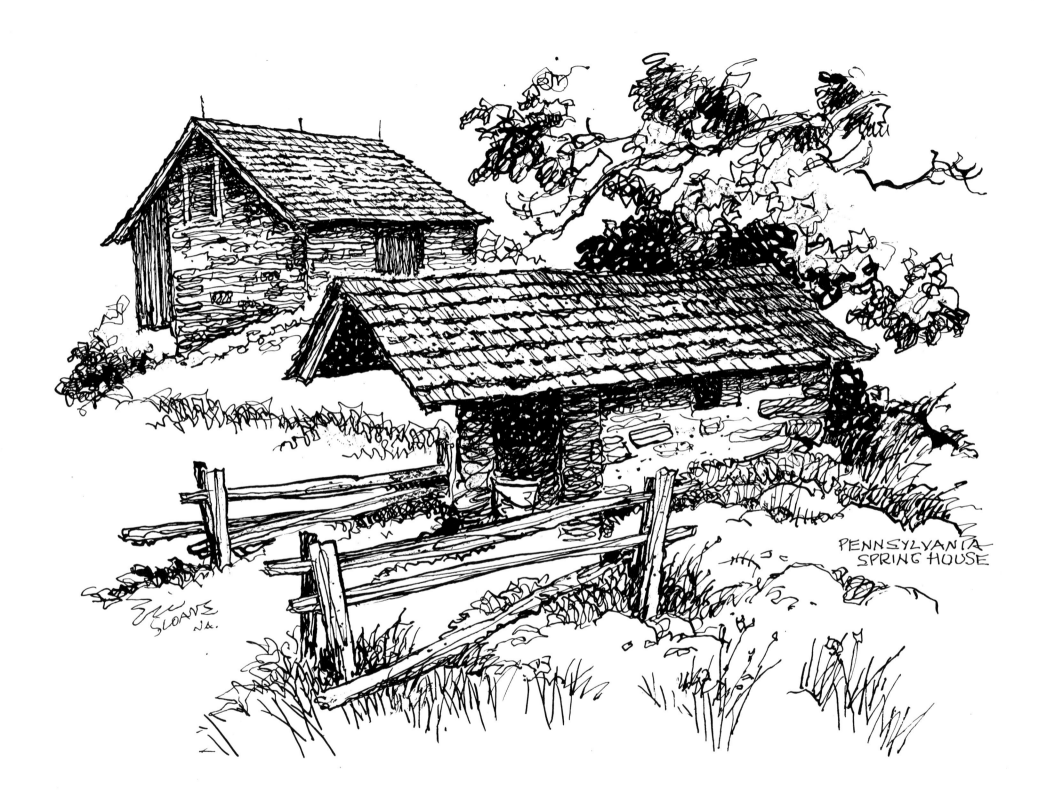

PENNSYLVANIA
SPRING HOUSE

EIGHTY
an American Souvenir

As all my writings have been somewhat auto-biographical, this brief account of my life and beliefs is likely to echo earlier works. I apologize to the reader who is certainly aware that a habit of old age is to repeat oneself but hasten to explain that I have always believed a good story is worth telling again. Songs were not written to be sung but once, Gilbert Stuart did quite a few Washington portraits, and Thomas Hicks did countless Peaceable Kingdoms. I've painted a thousand farm scenes and hope to do many more.

I believe that art involves remembrance and the next best thing to living my life over again is to make durable recollections of it in writing and painting. But then to share my life's awareness with others seems to complete the magnificent adventure and I am grateful for the opportunity.

Neither true autobiography nor diary, this collection of memoirs is casual recall and a means of simple thanks to my Creator. The painter writes his own biography in oils without realizing it and so does the writer constantly make portraits of himself. I am aware that autobiography is an exit from history but as trivial as my literary impact may be, I hope there may be those who might benefit or at

least be amused by the anecdotes and philosophy of my years of thinking with brush and pen.

I find keeping accounts distasteful, still I regret never having kept a diary. One's eightieth year seems late to start, rather a proper period for contemplating autobiography. There is a time for doing and a time for remembering. Recollection comes easiest during the autumn years. I forget what I had for breakfast, yet I can recall inconsequential moments of over half a century ago. I am hopelessly immersed in remembrances.

My habit of not dating letters, never balancing my checkbook, and never putting dates on my paintings is not carelessness; it is a deep personal superstition that ignoring time itself might be a secret technique to delay aging. I confess to having gained five years in *Who's Who* (giving my birth date as 1910 instead of 1905) and I hope sticklers will forgive that childish prank. Now, I am both proud and thankful for having lived so long.

If I had written a diary, it would not be the usual businesslike account suitable for IRS reference but would be done in the manner of the old farm diaries I've been collecting for so long. They have flavored my paintings and writings, and they have influenced my way of life. Those pioneers had a magnificent awareness, capturing the vagaries of nature and the parade of weather in remarkable prose. Their weather diaries described stormy days as "burdening," "discouraging," "fretful," or "sultry." A fair day might be "boisterous with wind" or "filled with life." An approaching rain was heralded as "thicke aire" with "distant echoes of thunder." A blizzard might be "fearful" or "blinding" while a light snow could be "a day of slow, pleasant flakes." Such colorful language is lost to present-day meteor-

ology, but we still hear of "sheep-herd clouds," "mackerel skies," and "mares' tails."

The early American who came from across the sea where weather is mild and without sudden change, soon learned to become weatherwise and know the antics of New World atmosphere. Folklore is generally frowned upon by modern scientists in spite of its unique accuracy. The saying of "red sky in the morning, sailors take warning, red sky at night is sailor's delight" is based upon the words of Jesus Christ in Chapter 16 of Matthew. Crickets inside and outside my house measure the exact temperatures to correspond with my expensive indoor-outdoor thermometer. I am constantly impressed with the weather wisdom of ancient days.

The old farm diaries were written by the rugged hands of burly men, yet I've found quotes from the Greek and Latin, and rich Shakespearean descriptions, sensitive passages from the Bible, and precious moments of life saved to recount in later years. Once I unearthed a little leather-bound diary written by a farm boy in 1805. Its historic account and sensitive language so moved me that I fashioned the contents into my book *Diary of an Early American Boy*. Walt Disney discovered that book and offered to make a film of it. Known for his avoidance of unnecessary expenditures, however, the great man offered me an astonishingly paltry sum. In such cases the author shares one half with his publisher, which would have left me enough for an inexpensive weekend.

"I am well aware of your frugality," I wrote back to Mr. Disney, "and I feel embarrassed at your offer. I so admire your work, however, that I'd rather give you the script for nothing, but I'm sure my wife (and my psychiatrist) would object to that." Then,

as an added tongue-in-cheek quip, "I might settle for two bucks."

Mr. Disney was not one for passing up a bargain, for I promptly received a check for two dollars accompanied by a many-paged contract for the film plus drawing books, toys, candies, and souvenir dolls in the image of an early American boy. I recall this daily because I still have Disney's framed check hanging over the toilet in my studio.

A year later, when there was a TV offer for the story of the early American boy, a group from the broadcasting company came to Connecticut in search of proper land and buildings for shooting the film. "We need a location to build the cabin," said the director, "and it will take a while to build it." I'd done enough research to know that pioneers worked fast. "I'll build it properly in about ten days," I ventured, "and who would know better

The Cabin Built in Ten Days

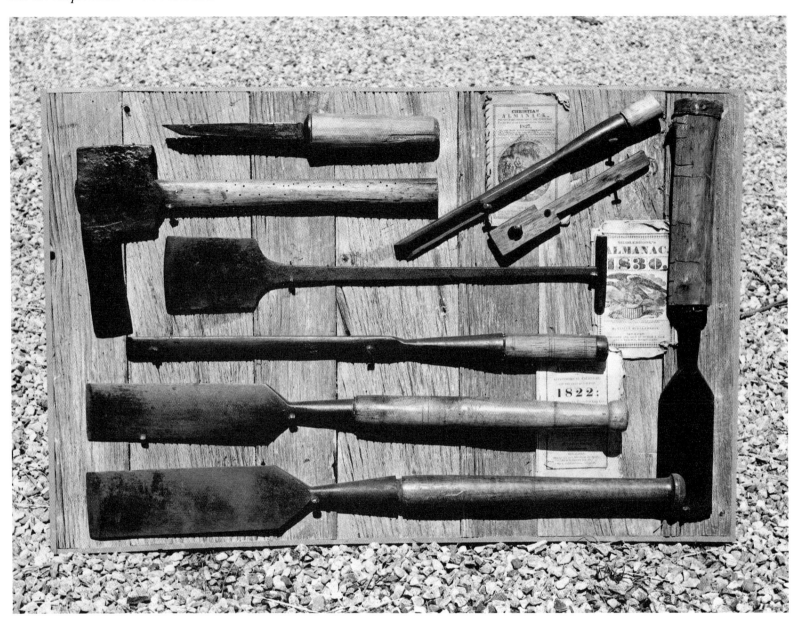

than I? I'm the one who wrote the book." They agreed.

I chose a spot near my Museum Collection of Early American Tools in Kent, for there I had all the implements available, and with an ancient spade I started digging the foundation myself. With two helpers to dismantle a stone fence from my own property and one man who knew how to use a frow to split shingles, the work began. Beams were broad-axed, rafters were split and within the promised ten days, the house of the early American boy, true to the description in the original diary, was ready for

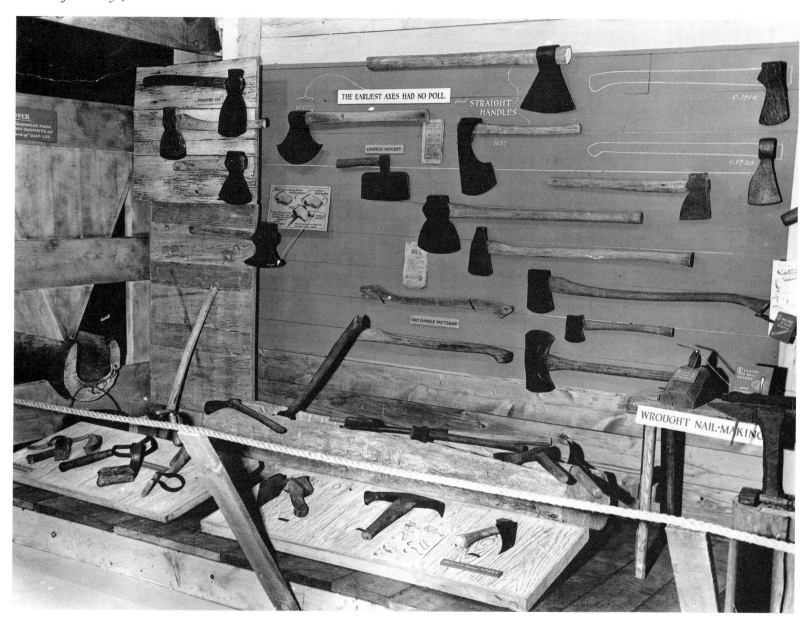

occupancy. It took a few days to find antique bottles to fashion glass windows and to make handmade hinges for the door, but no one was more surprised and satisfied than I.

One of the lessons I learned during my ten days of building was why the old timers seemed to pur-

posely ignore conformity, leaving doors off balance, rooms not squared, floors often tilted, and all floorboards narrower at one end than the other. Long boards were wider at one end, just as the tree they came from was wider at the bottom. A door properly off balance would automatically swing shut

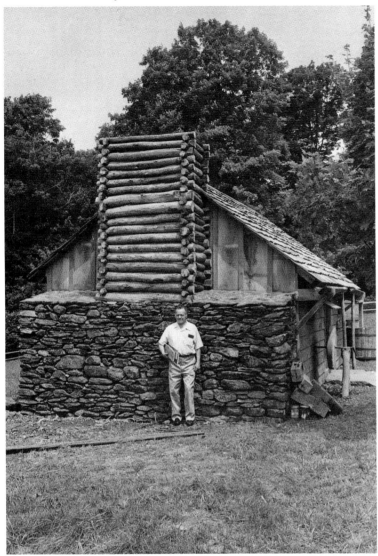

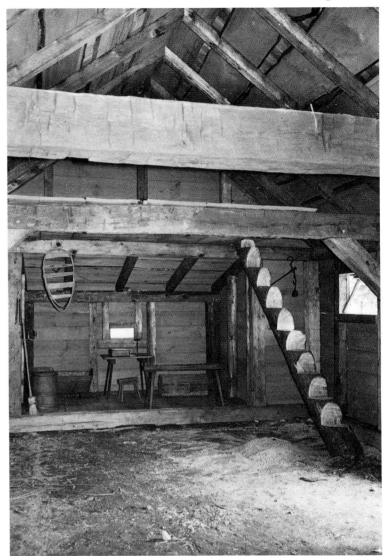

by itself. The explanation was largely that there seemed no sound reason for using a ruler or square. Furthermore, in their haste, proper conformity resulted; there was a lack of monotony, a composition of unevenness, a symphony of irregularities pleasing to the eye, and like a quick signature, there was something of the builder himself left in his work. Now, should I build a house, I might use a square only to make certain my work was *not* exactly square. And likewise when I paint, I make certain a building or composition in the picture is not monotonously exact. Perfection, I believe, is artificial: nature is random and artful.

When children visit the museum now, they compare the cabin with the one in my book, picking out this log ladder, that bottle window, the dirt floor, feeling the spirit of American pioneer days, imagining themselves living the historic experience.

The fact that I built the cabin of the early American boy in only ten days gave me a peculiar satisfaction, perhaps because it proved what I always contended (but wasn't completely convinced of), that the old timers didn't really have "all the time in the world" and worked remarkably fast.

On the night of the tenth day (it rained), I went down to the museum grounds and slept in the newly built cabin. An old American custom is to bring a new broom to a new house, so I first went to the museum and took from the collection one of the brooms made entirely from a single stick of wood. It was made over a century ago but its condition showed it had never been used. I deemed it a perfect talisman for the occasion and wondered what the original owner of the broom might have thought of my decision.

Noah Blake, the early American boy, had chosen a balcony under the rafters as his sleeping quarters and the entrance ladder consisted of a notched log, a one-piece wooden stairway. As I thought an electric flashlight was not in keeping with my secret adventure, I climbed onto the balcony by candlelight and when I blew out the flame, I was left in a pinewood-perfumed world of blackness, loud with the music of crickets and tree toads.

I didn't rest much that night, for I seemed to remember a past worth remembering, much too exciting to spend in sleep, a night of profound inspiration. I recalled how I had found a fine goose-wing broadaxe in the old stone fence nearby; I suppose some farmer had forgotten where he had placed it, over two centuries ago. The years had not dulled its edge, there was little rust, and the wooden handle still had the patina of use where a callused hand had polished it into a mirrorlike finish. More than an axe, it was pure sculpture, a piece of art worthy of museum exhibition, and so it had become the first of my tool collection that ended in the museum now only a few steps from the cabin where I was resting.

I contemplated my theory about the miracle of trinity—how so many things in life proceed in three stages. Finding the ancient axe had spurred me to find other early implements; then collecting tools became the second stage and, finally, the third stage of giving the tools away completed the experience. Each step a complete joy in itself, discovering, collecting, and then donating, comprise a lifelong satisfaction. It is strange how good things can evolve in the mechanism of life and how the past pleads to be heard. It was an unforgettable night.

I have always regarded art as some sort of remembering, contending that painting or writing is primarily communication of the author's remembrance, and so I have really been in the business of reflection. Bringing back forgotten emotion, searching the attics of America's past, I've sought to retrieve the country's abandoned treasures. Of course, there always comes the trap of nostalgia when the most magnificent sunset only reminds you of some earlier sunset. Finally, when everything begins to remind you of something else, it becomes difficult to differentiate between an appreciation of yesterday and a plain distaste for today. I regard nostalgia as a kind of disease and I cringe when my paintings are referred to as nostalgic instead of poems of awareness, monuments to meaningful antiquity.

One farmer bought a Sloane painting and then sent me a letter. "I like your barn painting but wonder if you could make a few changes. The barn roof

souvenirs of visits to abandoned farms.

needs repairing and there are broken windows that bother me. I expect to pay you but wonder if you could tidy up the building just a bit. A good barn means a lot to me as I am a professional farmer.'' My strained reply was an offer to buy back the painting. "The picture is exactly as I wished it to be," I wrote. "An old decaying barn means a lot to me as I am a professional painter, not a farmer." I still regret sending that curt reply but couldn't think of a better one. I love my work and hate my business.

Most of my half century of paintings have been souvenirs of visits to abandoned farms and early ruins. These themes, however, were not subjects; instead they were designed as symbols of American spirit. In other words, I have always attempted to make my subject completely spiritual. I sense dimension and proportion in ruins, and even after the building has fallen and timbers have disintegrated, there seems to be something still looming above a dead foundation. I contend that places can assume character, that landscapes can exude aura, that cer-

tain houses can have a haunting historic quality pertaining to those who once lived there. There are places that affect me by a profoundness stirred by sensitivity. If this be insanity, I confess and declare a fascination that only mad men know.

Once I entered a deserted barn and in the brooding stillness felt a haunting presence of the past. A slight gust of wind moved something metallic and a loose board flapped, producing sound like the stirring of animals in the stalls below. As I walked over the rotted hay, the exuding odor of bygone harvests rose to perfume the air, and I felt that I was breathing the same enjoyment that the farmer-builder once had. It was an aura of long ago reborn so eloquently that I wanted to share the enjoyment, and so I painted the first of some thousand or more barn pictures, all portraits of a spirit, not pictures of buildings. Real art depends so little on the subject, so much on the mood.

I guess I've come uncomfortably close to nostalgia for as I view the shelf of my books I see such cobwebby titles as: *I Remember America, America Yesterday, Once Upon a Time, Our Vanishing Landscape,* and so on into recollections of the dusty past. Luckily I've been aware that a great memory does not make a great philosopher; the past, I feel, should be part of the future. I suppose beauty is in the eye of the beholder, so no two people might see a ruin alike, but I feel that time consecrates life and the philosophy of age is a fascinating pursuit. Perhaps I have been painting ghosts, yet it seems a worthy gospel.

Age can produce either patina or decay; there is reverence in one, pathos in the other. Once my friend Jimmy Cagney, whose dancing and painting kept him young in spite of sickness, asked me to attend a luncheon with his old friends at the Players'

Club in New York. The ancient clubhouse is shrouded in Victorian gloom and the guests, who were mostly actors of the past, seemed to match it. When we rose to leave, I was amused and impressed with the fact that nearly every guest had his trouser fly ajar. As president of New York's Dutch Treat Club, I decided to tell that story and regale my club members with the fact that although we are creative curmudgeons, we are less senile, tidier, and more alert than the Players. But on the way out, when the attendant gave me my hat, he took me aside. "Pardon me, Mr. Sloane," he said, "but I notice your fly is open."

I find that modern America has a disregard for age and ruins. Nowadays only an historic plaque can insure a building against being demolished just for the purpose of constructing a newer building. When I acquired supervision of the ruins of an ancient iron furnace on the grounds of my tool museum, plans arose for reconstructing it, but my argument to leave it alone as a picturesque ruin finally won. Now visitors may see the rustic remains as a genuine piece of the nearly forgotten American past. Vines are growing over the stones and the old furnace has become a suitable monument to the memory of yesterday's builders. It didn't cost a cent!

We forget much more than we remember, yet the human brain is a computerlike clutter of data, forever waiting to be tapped. A song, a painting, a written sentence, even some sound, or a faint odor can trigger the memory to revive long-lost emotions, fresh as when they were first experienced. In fact, the passing of time often intensifies, making the picture more brilliant. That is why I seldom paint on location, recreating from memory instead. I have always felt uncomfortable seeing Sunday painters

the Poet's Brush

with propped easels, battling the weather and with sunlight in their eyes, trying to capture a landscape. God help them when they do a snowscape.

Very few painters, during their youth, escape requests to do public demonstrations and very few succumb to accepting. "People like to see how the artist works," the gallery owner will usually explain, although I know of no painter who works with an audience. When I made my mistake it was in the name of a charity and there was a full house. Even *The New York Times* announced it with the heading of BIG SHOW OF ERIC SLOANE, but that elite paper is known for its bloopers and it came out BIG SHOW OFF ERIC SLOANE. That was many years ago but it was a lesson with a lasting sting for I realized that a public demonstrator is indeed no more than an exhibitionist.

Just as poetry is a speaking picture, I consider a painting a poem without words. Sir Joshua Reynolds said, "A room hung with pictures is a room hung with thoughts," and Coleridge wrote, "A picture is something between a thought and a thing." What they were trying to impart is that true artists paint more with their minds than with their brushes and I do try to emulate them, painting thoughts and spirits and moods. The arts have a universal language understood best by aestheticians. It is always good to meet a brother in art: Whistler understood the language when he commented that, "as music is the poetry of sound, so is painting the poetry of sight."

I believe a true artist does not paint *things* as much as he recreates mood. So many visitors to my studio look out of the window and ask, "Have you ever painted this beautiful scene?" and my reply that "I might find richer subjects in my broom closet"

would probably frighten them, so I keep quiet. Many people are hopelessly sane. "Beautiful" pictures are for calendars and I confess some discomfort in admitting that I can find beauty in strange places: in dead trees as well as live ones, in storm clouds as well as calm skies, in the wrinkles of age as well as the smoothness of youth, in decay, melancholy, and desolation, for all these occur in nature. I do hope such an eccentric attitude does not suggest a disordered mind: perhaps my personal definition of beauty is in order. I believe that *beauty consists of all combinations of things in nature, or their reflections in art, that create pleasure and arouse emotions.*

I might as well confess, too, the eccentricity of believing in superstition. That word refers to "standing in awe of and amazement at the unexplainable," and in this age of miraculous wonders I am not embarrassed to be in awe constantly. Not being a churchgoer, I am no believer in conventional prayer, yet I believe that we make tiny (yet true) prayers, thousands of them each day without realizing it, questioning our inner selves and wondering about this or that. Each page I write or each picture I paint is the result of many such wonderings: "Is this the right word or is that the right color?" It may sound strange to regard these miniscule wonderments as answerable prayers and then to believe they are actually answered, yet this is my belief. When the result is gratifying, I even feel called upon to feel thankfulness for the small miracle. Superstition? Perhaps, but when time and time again the magic works, in awe do I accept it. I pray constantly, not on my knees, but with my work, and I believe that the Creator replies.

Whatever unusual or remarkable excellence occurs in my work is seldom of my own doing but

most often the result of what I call "happy accidents." Believing that the artistic mind itself is not creative but merely a catalyst and distributor for *re-creation* (a dispenser of some higher power), I work quickly (almost carelessly), waiting anxiously for something to happen miraculously, actually beyond my own ability. A splash of paint, a slip of the brush, or a quick stroke might produce an effect that I really hadn't planned, but which might be so good that I hasten to capture it and retain it as my own. The result might be a picture entirely different from what it started out to be, a work more the product of something "out there" than that of Eric Sloane. You might call this Zen, some might call it superstition; I choose to call such convictions my religion and my paintings icons of that belief. I believe God is something within us and that we exist for the purpose of expressing Him.

I so believe in this Zen-like theory that I paint with encouragement for "happy accidents" by starting quickly, often with a four-inch house-painting brush, always in a careless or sloppy manner, then using a smaller brush almost like an Ouija board planchette, hoping for the picture to paint itself. It usually does. I find a background of music helpful largely because it takes my mind away from my work. I'd rather not think about what I am doing. Such madness (at least for me) pays off, for I am constantly surprised and delighted at what appears on my easel, so often better than I could have done by myself. My youthful transition from sign art to fine art was an agonizing period involving the change from the business of painting to a philosophy of awareness.

Looking backward, my life seems to have begun when my mother died. From that moment I was on my own and so became myself. After my father remarried, I left home many times, yet cautiously avoided venturing too far. Then on one occasion, Dad gave me the family twin-six Packard roadster so that I might leave home in style. I found the gas tank quite full, but timidly brought up the subject of finances. I had no money. When Dad gave me twenty dollars, I was too bewildered to argue and so I took it and headed westward, unequipped, to tilt with fate. The twenty dollars got me only as far as Ohio and to a turning point in my life. Hungry, broke, and confused, I sold the car for fifty dollars and set out on foot as an itinerant boy sign painter. It was as funny as it was unfunny, but savored by a youthful sense of humor, it was a glorious adventure worth more than a college degree. I like to think Dad knew what he was doing.

It was in Taos, New Mexico, some forty books ago, that the idea of writing while wending my way back east by automobile seemed credible. Inspired by the eight-thousand-foot view of sky, I had decided to make meteorology and sky painting a life's work and, after all, the best way for me to learn a subject has always been to write a book about it. That was how my first book, *Clouds, Air and Wind,* evolved.

Henry Ford had not yet invented the glove compartment, but I shared the seat of a Model T with a traveling office of paper and pencils, a dictionary, and sketching equipment. I remember planning to make the journey back east in fifteen days because while buying provisions in a little Mexican grocery shop, I saw a five-foot bologna hanging from the ceiling, which I bought and divided into fifteen sections, one for each day. I lost my bologna somewhere in Ohio but by the time I reached New York,

The
Five foot
Bologna

Everard Hinrichs
signs and lettering
19 25

I had the makings of my book, sketches and all. The strange stench that permeated the last leg of my trip was found to be from the "lost" bologna which had slipped behind the seat and had been resting on a hot exhaust pipe.

I remember when automobile brake lining was made of a rubber composition that smelled something awful when you slammed on your brakes or drove with your emergency on, and so I devised a road sign for the Raybestos Company. I guess it was the only advertisement in America equipped with smell. Five hundred feet on either side of my unique sign was a small electrically operated stove that burned pieces of rubber. The sign itself said: "That smell was not YOUR brakes but it *might* have been!

Use Raybestos Brake Lining!" The town where I first erected the sign complained about "the stink," and my invention was short-lived.

As far back as the early 1700s, many American artists began their careers as sign painters and I can see why. The pleasure of creating a piece of work necessary to the buyer is a satisfaction beyond that of the artisan who paints merely to decorate. Some of America's finest and most prized examples of folk art are antique trade signs and inn signs. The signs I painted on midwest restaurant windows, even on hotel rest room doors, probably gave me more artistic satisfaction than anything I might have accomplished in art schools. I still letter freehand as easily

as I write script and still have profound reverence for classic lettering.

At the time, laboring at Bull Durham signs on barns or Red Man chewing tobacco signs on covered bridges was hard enough, yet it was always great adventure. Rainy days kept me inside dreary motel rooms, but even then I painted a supply of showcards suitable to sell or swap for meals in restaurants along the way. A favorite with lowly diners was:

WE'LL CRANK YOUR CAR OR HOLD YOUR BABY, BUT WE DON'T CASH CHECKS, AND WE DON'T MEAN MAYBE.

I had one for the more elegant dining establishments, which I lettered in "Old English":

SERENELY FULL THE EPICURE MAN SAY, FATE CANNOT HARM ME—I HAVE DINED TODAY!

Recently on a trip across country, I stopped at a tiny restaurant and saw one of those signs, which I had done over half a century ago. It was faded and aged but it brought back beautiful memories and the echo of forgotten laughs. A sense of awareness is a gift of God, but a sense of humor is a gift of mankind that tempers pathos. Winking at life exhibits a twinkle of comprehension and I believe an understanding God winks back.

I remember the last time I used my true name (Everard Jean Hinrichs) for I had set up a sign business in Lancaster, Pennsylvania, and had a suitable card printed with that name upon it. Otto Heinrich was a well-known Lancaster County decorator of the late 1700s, whose Fractur work was still re-vered; so as "Herr Hinrichs" I felt at home plying my trade among the Plain People. My card was done in Fractur fashion with distelfinks and tulips, and I got several jobs of painting so-called hex signs on barns, but the Amish religion frowned upon both signs and pictures. I tried to repay a kindness to one fellow, reminding him "a picture is worth a thousand words," but he taught me a lasting lesson. "Come to the bedroom," he said, and he showed me one word done in Fractur, framed, and hanging over his bed. The word was LOVE. "There," he exclaimed, "is a word worth a thousand of your pictures!"

When I left Lancaster to wend my way afoot toward the west, I decided to create a new *nom de plume* and chose the name of my teacher but added an *e* to the name of Sloan. I knocked off the first and last two letters of *American*, which left *eric* and headed westward as Eric Sloane.

I'm not sure if we laugh less in old age or whether there is just not as much to laugh at. Perhaps we even age quicker because we don't laugh the way we used to. Anyway, all the funny things of life seem to have happened so very long ago, and they weren't always hilarious at the time. As when my father left me his fortune, which was contested by my stepmother, and the many bills of a Long Island estate became overwhelming. I couldn't walk into town without being accosted by irate merchant creditors. So I used a huge cardboard carton from a new (charged) refrigerator, cut eyeholes into it, knocked out the bottom, and walked right through town in the box, going past bewildered store owners, but completely safe from harassment. Sanity can be boring: I suppose Van Gogh's madness released his genius on canvas, and Nijinsky's insanity became

part of his dancing. When I think of the things I did in my youth, I can hardly disagree with my father, who always considered me a bit crazy and wondered when I'd "settle down."

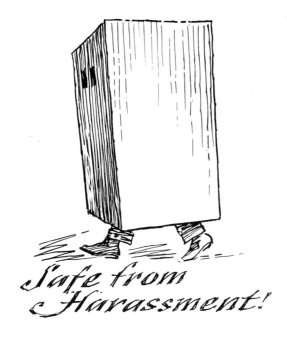

Safe from Harassment!

At one point in my youth I found my way to Coney Island. Steeplechase Amusement Park had burned to the ground and rebuilding it involved a great deal of fast sign painting. The inventive mind of the park owner, George Tilyou, always made hard luck an advantage. He fenced in the ashes and built a wooden walkway for people (at the sum of twenty-five cents each) to walk through the ruins and view the smoldering remains. Tilyou's mind continued to create and so I found constant work doing his amusement park murals and signs. The theatrical and amusement world was (and still is) superstitious about using the color green and to this day, I find myself avoiding green in my painting. I laugh to think how contagious is superstition.

I remember creating the "Tunnel of Love," a ride that was entered through a "Cave of the Giant Spider." I used tin pie plates for the spider's eyes and thin rope to weave a gigantic web, but I had trouble finding suitable stuffing material for the huge body. It was Sunday and the roller-coaster workmen's overalls were hanging in the park workshop—some fifty grimy garments perfect for bundling into a giant spider body. Came Monday the "Cave of the Giant Spider" was completed and when the park workmen arrived for work, a profusion of Italian profanity filled the air. But only I knew what happened to the overalls, and my giant spider was a great success.

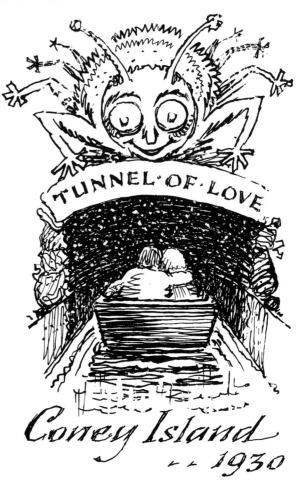

Tunnel of Love

Coney Island 1930

One of my transitions from sign painting and commercial art to the delicate and dubious world of fine art was a five-hundred-foot mural in Coney Island's Luna Park ballroom. I'll admit money was worth more in those days, but one dollar per foot (five hundred dollars for the whole job) was a real bargain-basement price, even though I used a four-inch house-painting brush and it took all of three days. Impressed more with price than ability, Feltman's Restaurant (they invented the hot dog) asked me to paint a two hundred-foot hot dog along their boardwalk entrance. Inspired by my Luna Park ballroom mural introduction to fine art, however, I felt it now below my dignity and so passed up the frankfurter job. I rather wish I had done it, however, as not many painters have painted anything like that; I'm sure Jasper Johns or Andy Warhol might have envied me. Being poor was no problem because that school of laughs and hardships was rich in youthful satisfactions.

During winter, Coney Island was delightfully barren. The tower penthouse apartment of the newly built Half Moon Hotel was all mine. My old friend David Martin had become manager and he found my companionship fair payment for rent. The hotel afforded a commanding view of the empty beach and the lonely boardwalk beside the broad Atlantic. Buoy bells lulled me to sleep at night. There was neither rent to pay nor charge for food. Room service and meals needed only my signature, as long as I made signs for the elevators, decorated banquet rooms, and lettered washroom doors. It was a boyhood dream for an art student. When tourist season arrived, however, I moved to a more modest hotel room, but still enjoyed the role of being artist-in-residence. I was given room 615, which Murder Incorporated had once rented, where court witness

Abe Reles had been pushed out of the six-floor-high window to his eternity. "It's not a popular room," David Martin told me, "but I'm sure you won't mind." I guess it was cheaper to have Eric Sloane murals on the hotel walls than flat coats of paint done by a house painter would have been. I had all the time in the world and I worked fast. The hotel soon became a museum of Sloane murals.

Sometimes I had distinguished helpers at the Half Moon, for the hotel was a fashionable place in those days and the immortal "Ashcan Eight" of New York's elite art world enjoyed the proximity of Coney Island's beach. Artists like Everett Shinn and John Sloan used the elevated-subway crowds and ocean bathers as life classes away from their studios and they used the Half Moon Hotel Lounge as a drinking rendezvous. There, while doing a mural in the bar, I met Reginald Marsh, who gave me pointers in depicting rotund Brooklyn lady bathers. Aviator Wiley Post climbed my ladder in the Aviation Room to personally sketch in the true proportions of his famous Winnie Mae, and speed demon Roscoe Turner arrived with Gilmore, the lion cub, who often flew with him, publicizing Gilmore Oil ventures. Because lions were understandably not allowed in the hotel dining room, Roscoe once used my room as a zoo while we had a late breakfast together in the hotel dining room. On my doorknob we hung a sign, "Please do not disturb—lion inside," and prayed that the maids responded. Gilmore, however, called for room service by a few thunderous roars heard six floors below, and our breakfast was cut short. Gilmore grew up and became so famous that you will now find him as a stuffed exhibit in Washington's Art and Space Museum, beside Roscoe Turner's speed plane.

Because the Half Moon was near Floyd Bennett

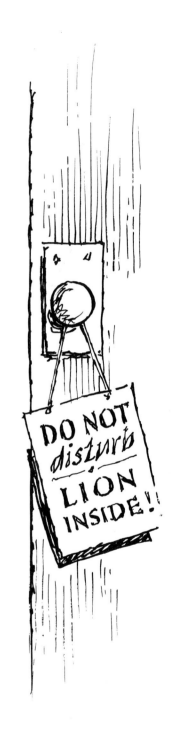

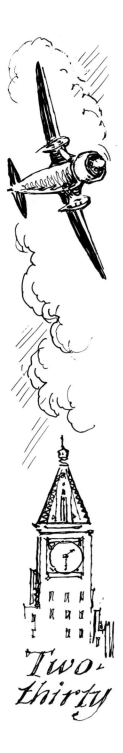

Two-thirty

Field (then having the longest aviation runway in the country), the hotel was headquarters for the many transoceanic flyers of that time. I recall Dave Martin waking me one dawn to witness such a flight. I shall always remember the pilot, Jimmy Mattern, on his knees for a brief prayer, while nearby the slow-moving propeller of the idling engine sliced the cold night air and its exhaust belched long blue blobs of high-octane flame with each revolution. Finally, as the gas-laden plane lumbered down the runway with us in the hotel limousine hard in its wake, we shouted encouragement to help the ship bounce into the dawn air and take flight over the Atlantic.

Floyd Bennett Field and Roosevelt Field (now a shopping mall) were theatres of historic aviation and rendezvous for a lost race of airmen. Nowadays flyers would feel embarrassed to be called airmen; with briefcases of computer instructions, they look more like office workers, but in the twenties there was a camaraderie that put flyers into a special class. Riding pants and puttees, turtleneck sweaters, goggles, and white scarves were common; once a flyer had made a name for himself, however, he designed his own uniform. Roscoe Turner had a baby blue military uniform, elegant with gold eagles that gave him the appearance of a banana-republic general.

There were good boys and bad boys, test pilots and show-offs that made aviation rich with anecdotes. I remember one foggy night when a group of them were playing cards in a hangar. The hour was late and the night drizzly. "Let's call it quits," said Al Williams, the Gulf Oil speed king. "Anyone got the time?" No one seemed to have a watch, but bad boy Bert Acosta left the table, opened the hangar doors, swung into his Laird Special, and with hardly enough time to warm the engine, was airborne before the ship left the hangar, lifting into the fog of night. Heading for Manhattan, he circled the Metropolitan Life Insurance building's big clock and returned in a matter of minutes. "It's about two thirty," he announced, "and I guess there's time for another game or two."

My work as sign painter came in handy because experimental planes were always changing license numbers on rudders; besides, most flyers liked personal emblems on the fuselage. I painted designs on most of the famous transatlantic ships and race planes, and it soon became a flying superstition to have young Eric Sloane do the job as a sign of luck. Famed pilot de Pinedo, however, chose not to have young Sloane do a lucky emblem and he never left the ground on his transatlantic try, ending in a tragic explosion of gasoline fire against the wire fence of Floyd Bennett Field. From then on, I was kept busy as sign painter to the adventurers of aviation.

When singer Harry Richman chose to try his luck, filling the wings of his plane with Ping-Pong balls in case of an ocean ditch, he handed me two one-hundred-dollar bills and a scribbled note saying LADY PIECE. "Paint this on both sides of the cockpit," he said. Fortunately I realized he just wasn't a good speller and so his ship made the trip as LADY PEACE.

More recently, when I painted murals in the Air and Space Museum, I accidentally bumped my scaffold against a hanging Beechcraft Bonanza that I'd long forgotten. It was the very craft I'd flown in with the famed flyer, Bill Odom. I suppose Bill Odom's name is now forgotten although when he circled the globe in the Reynolds Bombshell, he was a national hero. The Winnie Mae also hangs in that

museum with some of my lettering and I remembered flying in it with Wiley Post. "Someday," said Wiley, "a fellow will come along and paint nothing but the sky itself." He was right, for the idea struck me forcibly and I spent the next year doing my first cloudscapes in oil. That attempt resulted in my first sale. Amelia Earhart bought it.

It then made sense to me that, before embarking upon a career of painting clouds and sky, I should first learn all I could about the weather. A meterorological stint at M.I.T. proved to be a study in dull mathematics, without the romance I'd hoped for. The best way for me to learn a science quickly was to write a book about it, so I wrote a manual on weather. The Air Force liked that enough to use it as a quickie wartime publication. "It explains weather nicely for the novice," they wrote, "and Sloane talks *with* the reader rather than over his head. He makes it sound as if he were actually learning along with the student reader!" Little did they know that was exactly what I was doing.

I never liked the Latin nomenclature so often used in scientific language and took particular exception to the word *meteorology*, a name persisting from the time when we thought weather was caused by meteors or "falling stars." So I coined the word *Airology* and a new word was born. It was even copyrighted when my Long Island studio was called "Airology Inc."

Sverre Petterssen, my teacher at M.I.T., gave me encouragement in the foreword of *Clouds, Air and Wind*:

Artists have strived for centuries to express nature in colors, forms, and symbols, but only rarely do we see the sky itself as an object of art. Eric Sloane is not primarily interested in mountains and meadows, castles and cattle, hills and horizons. His main interest is centered around the mountains of clouds, meadows of fog, hills of stratus, the skycrapers of storm clouds, and the castles of air.

Sverre Petterssen
Cambridge, Mass.
October 1939

While writing the book, I thought I might find meteorological material in the American Museum of Natural History in New York, but they had nothing there about the atmosphere. "What you are really looking for," they told me, "is a museum of *aviation*—not a museum of *natural history*." They didn't seem to realize that natural history exists only within atmosphere! "There's no natural history on the moon," I explained, "because there isn't any atmosphere there." Finally, they seemed anxious to get rid of me. "You may be right," they said, "but at the present time we haven't enough money to start a hall of weather. Come back with a donor some day and we'll consider it." I assured them I would do so.

Within a week I returned with a donor (William P. Willetts) who wanted to donate a memorial for his Navy son, who had been killed in an air accident. We used Bill's handball court as a factory, and I began working on glass-encased, three-dimensional models of clouds, cold fronts, warm fronts, hurricanes, and all the phenomena of weather. With blue lights for descending cool air and red lights for ascending warm air. I invented atmospheric movements by little fans over light bulbs (like those that imitate moving flames in artificial fireplaces). It be-

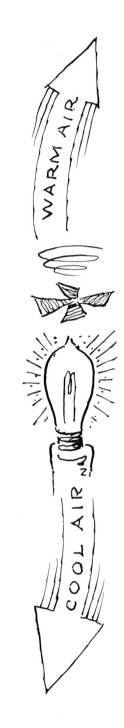

came the first Hall of Atmosphere in any museum.

Since then, years of revolving began to wear out the propeller fans, the white cotton I had used to simulate clouds became black with New York City soot and finally, the "Willetts Memorial Hall of Atmosphere" became obsolete. But I had the satisfaction of having created the world's first museum hall of weather.

I remember showing the same set of three-dimensional models of weather at Columbia College. After setting up the exhibition for proper display, I switched on the electricity and an old German science professor was passing through the room. "Ach!" he exclaimed. "It's *beautiful! So realistic!* The clouds and even lightning!" Actually there was no lightning in the display, so I looked to see what he meant. The college had not been wired for AC current yet, and the old DC current had set off explosions in my displays, which had set them all on fire.

Those were the days of early television and one friend suggested that if I wanted to learn more about weather, I might pioneer by being the first television weatherman. The Dumont station in New York said it would take only three minutes of my day, at seven in the evening. But going downtown to the Weather Bureau to study government weather maps in the morning, back to the television station at noon to prepare the show, and then being made up (they all used heavy makeup in those days), took up the whole day and my seven o'clock show left me exhausted after the "three-minute" effort. That adventure did not last very long. Painting was easier.

Making a living as a fine arts painter was not easy for a young fellow, and so my sign painting kit was often busier than my easel and I suppose, if I were not as stubborn as I am, I'd still be painting signs. Yet half my days were filled with making fast sketches and just as speedy "practice oil paintings," which I always destroyed or gave away. My advice to young art students still is to do many fast works, but unless you are satisfied with them, throw them away. And do try to *seldom be satisfied.*

The art of destroying early work is frowned upon by most collectors, but I wish I had learned to do more of it in my youth, for I gave away paintings as birthday, Christmas, anniversary, and wedding gifts, reasoning that it was all I could afford. I even left paintings as tips to waiters. Now I buy back all I can, just for the purpose of destroying them. One waiter (from the old Rothman's Restaurant on Long Island) died and in his will left his son enough "tip paintings" to have his own Sloane showing at a prominent art gallery. It turned out to be a sturdy legacy for the son but a sad showing for you know who. The fine art of destroying whatever you are not satisfied with is one of discrimination and courage, which I highly recommend.

There are those who carry portfolios of their work, which they always "just happen to have" with them—nostalgic student examples that should have been discarded long ago. Actually, you can't discard or destroy recollections, and the mind itself is the artist's best portfolio. I have done dozens of sketches of the exact same subject, each time throwing them away, each time trying to improve. As Oscar Wilde said, "It is good to have the simplest of taste, only being satisfied with the best."

In 1924, a building material was invented called Masonite. I happen to know this because, in that year, a salesman gave me a batch of new samples. "I can't seem to sell this damned new stuff," he said,

"and as a sign painter, you probably can use them for making signs." It was when my career as a serious painter began, and so my first paintings were done on those free samples. Now about half of all paintings done in America seem to be done on Masonite. The first painting I did on Masonite was of the adobe mission at Ranchos de Taos in New Mexico, the famous "mud cathedral." It turned up at Fenn Galleries in Santa Fe and I hoped to buy it back as a conversation piece, but actor Robert Redford had beat me to it. The sixty-year-old Masonite souvenir now has a good home in his living room.

Sadly, the modern idea of competition is often manufacturing for *less*, rather than a quest for *quality*, and so, like many other things, Masonite isn't exactly what it used to be. The better mousetrap theory is out of style nowadays and we seem to find more competitive success with cheaper mousetraps instead. Norway and Sweden seem to have more moral business philosophies, for that's where I now find the best materials to work on.

The values of working on board instead of canvas have been most important to me. Canvas breathes with weather and in time breathing cracks oil paint. Canvas tears and shreds, while board is nearly indestructible. I recall attending an exhibition of the paintings of Mrs. Norman Mailer (his wife *du jour*), who worked with thick globs of paint, using a palette knife. When I touched her painting to feel the extraordinary thickness of paint, she reprimanded me harshly. "Evidently you don't frequent galleries!" she said. "One doesn't touch works of art!" Later, when she attended one of my own shows and she needed a light for her cigarette, I used a wooden kitchen match and, reaching toward one of my land-

scapes with a stone wall in it, scratched the match against a painted rock. I assumed she remembered her reprimand, and I had proved the stamina of Masonite.

Board (unlike canvas) can be sawed to size: just as photographers cut or "crop" most of their pictures, I do likewise, sawing my paintings, cutting them down to proper composition dimensions. A four-foot painting might end up half that size, the better for having been changed. You can't do that sort of thing with canvas, which must be tacked to a stretcher. My first gold medal was won with a painting that I had sawed almost in half to fit the size requirements of the show. A saw is an important part of my studio equipment.

My left hand shows the effects of careless sawing of Masonite paintings. Even my nose has suffered, for once upon a time, when I tossed a Masonite painting into the loft of my barn studio, it bounced back in the darkness and struck me on the bridge of my nose. I regained consciousness, wondering why I was lying on the floor and what I was chewing on. My nose was in my mouth and it took 42 stitches to get it back in place.

Another maverick studio habit is my use of plain (unleaded) gasoline instead of turpentine. My theory is that gasoline dries quicker than almost anything else, disappearing completely but leaving pure oil paint behind. True, my workshop smells more like a garage than an artist's studio, and a fire extinguisher is part of my equipment, but the results have been satisfying. Breaking the wooden handles of my paintbrushes and using the stubs to scrub and simulate grass patterns in wet oil paint is another effective trick: I use the wrong ends of brushes almost as often as I use the proper ends. The use of rags, razor

the Artist's Tools

blades, and ebony pencils applied directly into wet oil paint adds to my list of outlandish easel practices. My favorite birthday and Christmas gifts are bundles of rags which understanding friends still send religiously. So many old friends are dying lately that I now buy cases of new sheets to tear into rags.

Custom is a law of fools and should not be a requisite of art; I'd use chocolate bars as art material if that gave me a desired effect. The mention of chocolate bars recalls one on-the-spot sketch I did of Taos Pueblo, when I didn't have a pencil but did have a Hershey bar which served the purpose. I must admit a pencil might have been better, but the sketch was framed and it now hangs in a friend's home. "Don't hang it in the sun," I suggested. "Chocolate melts."

A painter's easel, particularly if owned by as sloppy a fellow as myself, soon becomes a meaningful work of art. I've often wondered what became of the easels of great masters. Imagine the romance and value connected with the easel of Rembrandt or Rubens; I'd almost rather own their easels than some of their paintings. My own easel has become a masterpiece of smears, globs, and spills, the results of a few thousand paintings, as rich in design as a Jackson Pollock and as much a part of me as anything I know. Only my easel shows evidence of the trials and successes I've had, the adventures in mixing magic colors, the secret of how long it took to do a painting, and the pleasing agony of capturing mood in oil paint.

It is surprising, interesting (and damned annoying!) how many people ask the painter how long a painting took him to do. It so happens that the very few paintings I have done which tended to satisfy me, were the ones that happened to take the least time. Likewise, I have worked for weeks on a paint-

ing only to give up and destroy it. Trying to save such a fretful piece of work is like trying to save a hopeless marriage. I've had half a dozen divorces: likewise my wastebasket is usually filled with sad, discarded oil sketches.

The best example of the merit of speed and the practice of not working laboriously, is to consider your own autograph, which, when done properly, is spelled out with a steady swift flow. Take a full minute to do the same autograph and it ceases to be genuine. But a quickly done autograph (like a spontaneous painting) is a most individual creation, difficult to forge.

Often a first quick sketch has more aesthetic quality than a finished piece of work, for the merit of a picture can be deleted by over-painting. Picasso wisely said, "An artist should be two people—one who knows how to paint and one who knows when to stop." During his late period, his success was remarkable because of his talent in knowing when to stop. Robert Henri was an advocate of speed. "Work fast," he told his students. "First relax as if you were getting ready to do a high dive. Then when you are damn good and ready, pour yourself into the painting and work as quickly as you can. The result is often astonishing."

If I were a teacher (Lord forbid, for I claim art cannot be taught), I'd rather see a student do seven drawings in seven days than use a whole week on just one. But the art of speed is tricky and must be understood; speed will save your life on thin ice but they who run fast on land are apt to stumble.

One illustrator who specialized in women's fashion used many hours drawing and redrawing a solitary figure. At the end of a week's tracing and carbon papering, he'd settle on a satisfactory pose

and pencil the result lightly on his bristol board. Then, after a cigarette, a drink, and a short rest, he'd take a deep breath and tackle the final drawing, racing his pen over the paper, doing the finished art in less than a minute. It had a stylish nonchalance, a debonair lack of concern and the casual indifference of a master. To be sure, he did it in less than a minute but it also represented a week's hard labor.

I remember once wanting to do a painting to capture the mood of a closed summer place. As a young boy, my most touching recollections surrounded the opening of the family vacation house in the spring and its closing at the end of each summer. I can still smell the odor of damp leaves burning in the spring, the dankness of wooden dresser drawers that had been closed for a whole winter, and the dusty pungent air stirred by having removed storm doors. Just as poignant to me was closing time in the fall, when all the excitement of vacation days was shut up into the empty house, rocking chairs were tilted against the porch wall, and rowboats were drawn up on land in preparation for the long winter. I spent what seems like a thousand hours during two years seeking the proper house for my model. The actual family summer house of my youth had previously burned down and I could not find a duplicate.

Then one late autumn day, while hiking along the shore of a country pond, I came upon a closed summer place. A rocker was tilted against the porch wall and the windows were shuttered. I wondered aloud, is this what I have been looking for—is this the proper subject for my painting? Instantly, an unexplainable thing happened. A large tree nearby shuddered and fell to the ground. I suppose it was so old and rotten that it was long overdue to fall, but the timing was miraculous. My wonderment, my

tiny prayer, had been answered. My thousand-hour search was ended and I hurried back to the studio to do a painting that took exactly three hours. It is still one of the very few paintings that has satisfied me, and in case people want to know how long it took me to paint, I tell them that I did it in two years and three hours.

Always interested in criticism and what others think of my work, I like to mingle with viewers at my shows and eavesdrop. One aged farmer lingered at a farm scene. I wasn't sure if his eyes were blurry with age or if they were teary. He was alone and speaking to himself. "I wish my wife were alive to see this." It made my show a success, better than a sellout.

The remarks at my shows have been worth a chuckle even at my own expense: "Is he the ashcan Sloane?" "No, that was his father. This one doesn't do ashcans." Another favorite was: "The N.A. after his name means *non-abstract*." Or when the gallery owner said, "Would you like to meet the artist?" and the reply was "Nope."

Madcap TV comedian Henry Morgan once built a house on Cape Cod near a lighthouse and so I gave him a housewarming gift, a painting of "his" lighthouse. But hidden within the frame were batteries that caused a tiny bulb in the tower to blink every now and then. Before I presented the painting to Henry, I included it in one of my shows, where it did little credit to the world of art, or to me. But what the world needs is more laughs and so it served a purpose.

Just as most of rural New England is dotted with church steeples, I have seldom painted a landscape without adding a distant white spire, like a Sloane signature. Once when I bought the work of a fa-

to
Laugh

mous Hudson River School painter, I felt the urge to forge such a touch. Later when I donated the piece to a museum, an art critic called attention to the distant church. "That faraway spire," he wrote, "is the final touch of the painter's rare genius." I suppose I should have deleted the forgery before donating the painting but I'm sure the artist, who has long departed, would forgive me and, from his location, understand.

My penchant for church steeples has long been an influence, and I had always hoped to buy an actual steeple to decorate my estate, probably as a summer house or gazebo. So when I moved to Warren, Connecticut, and found the Warren church in the process of being remodeled, with the old steeple dismantled and on the ground, I could not resist buying it. The structure, however, proved a bit too narrow for a gazebo and I found myself the owner of a church steeple without knowing what to do with it. I did consider just standing it in my meadow, so when it snowed I could jest with my wintertime guests, saying, "See how high the snow gets out here!" But after a while it was broken into kindling and I found a strange satisfaction from being warmed that winter by the heat of a church steeple.

The New England church spire was actually designed as a "finger of Christian man" pointing toward heaven. Later when I painted the southwestern scene in New Mexico, I found the same symbolization in the American Indian kiva (underground holy place of worship). The ladder that descends into the kiva always leaves extensions of the upright poles pointing to "Father Sky" (the Indian God). There where the Indian prays in the confines of Mother Earth, the kiva poles point exactly like the white man's church spires, toward Father Sky. And whenever I paint a landscape with an Indian pueblo, I yield to penchant and decorate it with a kiva and kiva poles.

Because I think that being a painter is more a way of living than a profession, it seems logical that to learn art is largely to learn a way of life. Teachers so often become technicians and craftsmen without teaching the beliefs and motives and values that the classroom was originally designed for. Kindling minds is a clever and beautiful profession, and the highest function of a teacher is not so much to impart knowledge as to stimulate the love and pursuit of it. I remember George Luks and John Sloan, Robert Henri, and that coterie of art teachers of the early twentieth century: I learned much from them, yet what I learned had little to do with classrooms. Instead, I learned to think and live like a painter. Henri urged his students to "be a man first and be an artist later." Hallelujah!

Nowadays, when painters (like art itself) have lost profundity to simple craftsmanship and inventing, almost anyone can call himself an "artist." Some even claim to be "creative artists" although we know there could only be one Creator. Artists should *re-create* rather than try to create, still there are a lot of self-styled Jehovahs in the galleries. Will Rogers put it nicely when he said, "If a man ain't nothin' else, then he's an artist. It is the only thing he can claim to be that nobody can prove he ain't."

I regard many "works of art" as more invention then art and believe that some modern galleries exhibit inventions instead of art. Once cornered into being judge of such a show, I was confronted with walls of "mixed media" contraptions and untitled mysteries. Curmudgeon that I am, I gave first prize

First prize!

to the air-conditioning panel. At least I haven't been asked to judge a show since then.

When I was young there were heroes. The world was full of them. There were great painters and actors and writers that children idolized and tried to copy. Probably Lindbergh was one of the last American heroes. Now there are so few whom children look up to, except perhaps some seven-foot-tall basketball player. Even the astronauts, those who walked upon the moon, are quickly forgotten.

Only a decade ago, when the Smithsonian wrote to me asking if I'd like to do a seven-story, block-long mural, I invited "any Smithsonian representative" to a Dutch Treat Club luncheon in New York so I might discuss it over drinks (and graciously refuse the job). They sent a young fellow named Mike Collins, who was introduced to the club members just as "a guest of Eric Sloane's who works for the Air and Space Museum in Washington." I'd never heard of him before (to my recollection) and neither had the club members.

"Look here," I pleaded, "I'm an old fellow not used to heights. Even at your age, would you enjoy

working on so lofty a scaffold?" He didn't seem impressed. "I really wouldn't mind," he replied, "and I don't mind heights. I guess you didn't realize that I've been to the moon as an astronaut." How we forget the truly great! I did the job, for after such an embarrassing moment, how could I refuse famed astronaut Michael Collins?

Later, at the opening of the museum, I found myself in the auditorium between Jimmy Doolittle and Neil Armstrong, rising to make a speech about aviation. "We are in an age of forgetfulness," I started, "of apathy and mediocrity. But this museum is a monument to the 'greats' in aviation. We must recall the famous of yesterday because all the great American heroes are gone and forgotten." A loud cough of disapproval from my wife in the audience caught my attention, God bless her, for I then added, "Except the man at my right and the man at my left." I myself had forgotten the first human being to step on the moon and the other, the major American hero of wartime flying.

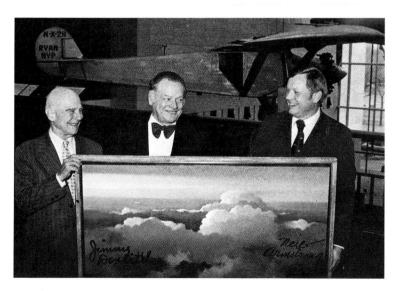

Doolittle, Sloane, Armstrong

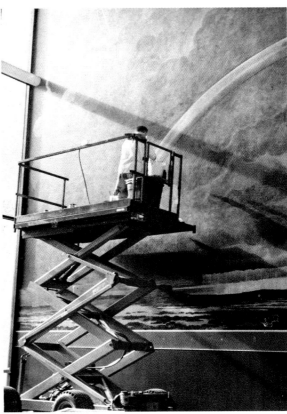

Jack-in-the-Box

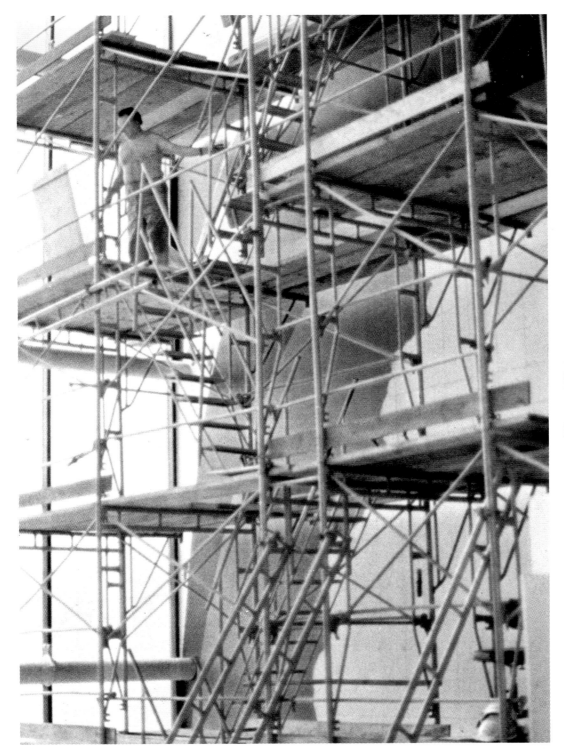

Seven-Story Perch

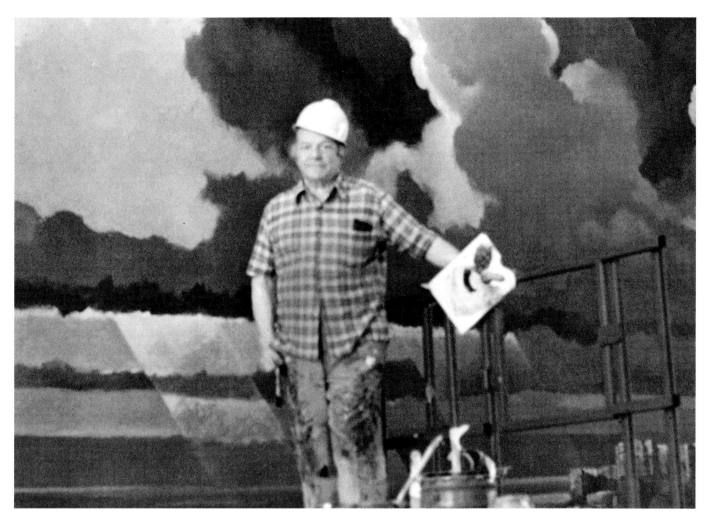

Scaffolds

The lower part of the air-and-space mural was done from a jackknife scaffold that went up and down by electric power. One evening when the cord fell out of the electric socket and I didn't relish staying aloft till morning, I had to shinny down the zigzag scissors. The eight-story scaffold was shaky but had ladders for easy escape.

When two gay fellows from the very modern Hirshhorn Museum next door sauntered in to view the scene and exclaimed, "The whole thing is ex-quisite—but it should be in a modern art museum," I thought they meant my mural. "Oh no, . . ." they explained. "We are not referring to the painting. We were talking about your scaffold."

Oil paint would have faded and would need frequent cleaning plus varnishing, so it was imperative to use that popular everlasting plastic known as acrylic. But acrylic dries like lightning and needs water as a constant and instant wash; two helpers stood by with water-spray pumps but not for long.

Wet and perplexed, I dismissed them and managed to do the job in three weeks, eager to get back to my beloved oils and smaller jobs.

Because art schools were supposed to teach art, I frequently found myself in such classes. But even then, a distant voice always suggested that art should be a psychological pursuit rather than the study of academic craftsmanship, and so I was never an enthusiastic student. That same voice has become more distinct in my old age and I am all the more convinced that "know-*how*" is less important than "know-*why*." The art student who learns first *why* he wants to paint, has already accomplished the most; only then should he be prepared to learn *how*. Anyone with the time and given effort (I feel) can learn how to paint, but true art is an understanding born from within. If only art schools would stress that!

I believe that an artist is not simply one who can sing or dance or design or paint (almost anyone can do these things with a smidgeon of talent plus a lifetime of effort). The artist in any profession is essentially a *sensitive person*. The sensitive mind sees and hears and feels what others cannot. And the true artist does not paint just for the joy of his own self-expression. He exists for the purpose of passing on his peculiar awareness to others, thereby enriching them so they might enjoy life as much as he. Art, then, is more communication of knowledge than an exhibition of talent. And when a writer or painter knows that he has communicated his awareness, there is no greater satisfaction.

Knowing that so many look at the sky without really seeing it, preaching the gospel of the upward glance has done my heart good. Every now and then I receive telephone calls about a sunset sky or some other atmospheric phenomenon. "You don't know me," they might say, "but quick, look to the west and you'll see a typical Sloane sunset!" The call might have come from a few hundred miles to the west, while it is already dark where I am. But at least I would know I have done the good deed of making someone aware, and I would sleep well that night.

Self-expression has been saluted in many walks of life but in painting, I think, it is often overdone. The real value of self-expression (to me) depends largely on *what kind of mind does the expressing*. This sounds opinionated, but I'll stick with it. Ruskin agreed with my philosophy when he wrote, "All that is good in art is the expression of one soul talking to another, and it is precious *according to the greatness of the soul that utters it.*"

Expressionism is a beautiful word on its own, but in the art world, it opened the door to shock and fad. To those critics and galleries devoted more to prestige than to art, it has often become a fanatic religion. The ridiculed man on the street who "doesn't know much about art but knows what he likes," still has my respect; I'd rather be his brother than addict to most of the "isms" that have sprung up since "impressionism." Impressionism was so new and exciting that when painters became inventors they also invented their own titles, and so expressionists were born, along with cubists, surrealists, dadaists, and so on into an endless world of isms. I am proud to be just an old-fashioned purist impressionist.

The difference between the impressionist and expressionist is as controversial as the difference between genius and insanity. Augustus Saint-Gaudens said that "what garlic is to a salad, insanity is to art," yet his own work remained sane, logical, and under-

CUBIST
ISM
DA-DA
POP
FUNK
ISM
SURREALIST
ISMS
MODERN
FUTURISTIC
ABSTRACT

standable. As for myself, I can enjoy garlic, too, but don't expect all others to share in my breath.

Once upon a time, when I found the art sent abroad to "represent American art" offensive, I decided to speak out. I spoke out with a show of thirty-seven paintings of American scenes designed to show peasants abroad that America was not all funk art, cowboys, skyscrapers, and hot dogs. (To call someone a peasant nowadays is an insult, but to me a peasant is a rare and beautiful person who is close to nature and loves the earth. Oh, to be a peasant!)

When I finished the exhibit, I put all thirty-seven paintings into book form, calling it *I Remember America,* having no idea it would reach Russian Premier Leonid Brezhnev. Nor did I dream he would ask me to show the collection in Moscow's U.S.S.R. Academy of the Arts. It was only a two-week show, but it did reach thousands of those beautiful people, the peasants. I think it did much to properly introduce America to many misinformed Russians.

Through the sponsorship of Pepsico's Don Kendall, I presented the Russian people with one of my paintings, two antique sickles hanging together; one was of Russian design, the other early American. The painting, however, ended hanging in Brezhnev's home. His letter of thanks was a masterpiece of national propaganda: the typical Communist diplomat can hardly say hello with stressing "peaceful coexistence." The letter read as follows:

Dear Mr. Sloane:

I was glad to receive as a gift your painting of sickles which symbolizes the peaceful labor of the people.

I fully share your opinion on the great importance which the ideological content of a painting has in the real art which reflects mutual expectations of the peoples, their aspirations for peace and peaceful labor, for friendship and cooperation which deserves the greatest respect and recognition. I was glad to learn that your exhibit in Moscow was highly appreciated by art lovers of our country.

Wishing you further success,
L. Brezhnev

In Russian language the word Sloane means "elephant," and indeed I felt as out of place in Russia as a pachyderm. As I feel about most trips away from the United States, my greatest thrill in travel is always during the return. A voyage away from my easel only gives me a deeper appreciation of home. My wife, whose highlight of a recent tour was seeing the Taj Mahal by moonlight, was understandably annoyed at my disinterest in travel and the fact that I'd rather make my annual drive up Connecticut's Route 7 to see the New England fall foliage. Even when I stay at my place in Santa Fe, I find the bittersweet rigors of the Northeast haunting me and I begin to feel like Thoreau in Palm Beach, longing for the pleasure of lousy New England weather.

Actually I built the Santa Fe studio inspired by my half-century-old dreams of nearby Taos and my memory of when, as a young itinerant sign painter, I came to that little village of artists. I thought going back to the Southwest might be refreshing in my old age and give me subjects different from those of the Northeast scene. But I soon found myself in Santa Fe painting New England just from memory. I remembered the words of artist Leon Gaspard with whom I lived in Taos during 1926. "The mind is an infinite source," he said, "full of plaintive songs; and I'd rather paint from a song than paint from life."

There in Taos, he painted the Mongolian scene, which, intensified by time and distance, was more vivid than if he had actually painted in Mongolia. I still agree with his colorful logic: I paint the Southwest best while I am in Connecticut and, when I go to Santa Fe, I paint my beloved New England.

Now after sixty years of being a painter I should be able to define my vocation. Yet the simple fact that I cannot define art is a requisite that entitles me to consider myself an artist. Art is as indefinable as love, a kind of confession that the artist is compelled to constantly and uncontrollably confess. Artists have described art nicely without trying to define it. Zola said, "I came in this world as an artist, to live out loud." Picasso said, "Art is a lie that makes us realize the truth." Ruskin said, "Fine art is that in which the hand, the head and the heart of man go together." Shaw said, "You use a mirror to see your face: you use art to see your soul." Every man's work is a portrait of himself but art is man's attempt to portray the Creator within us. Another example of the trinity, the artist paints first for himself (as a child), then for mankind (as a professional), and finally, with neither thought of himself nor of mankind, he paints for eternity.

Such is my philosophy. In all things there is a beginning and end but in spirit there is a difference. Art, which is truly a spirit, has neither beginning nor end for it communicates with the dead and unborn. I believe the artist is dedicated to the defeat of death, a champion of life. An ancient graveyard in Martha's Vineyard has the remains of an artist, a lady who left a rich legacy of her thoughts and beliefs; the tombstone says simply SHE DID WHAT SHE COULD. There can be profundity in triteness and if I should choose my own epitaph I could not think of a more profound statement than:

Being neither demonstrative nor Catholic in my way of life, I have always felt uneasy saying grace at the dinner table, but being blessed with a consciousness of gratitude, my uneasiness is no lack of thanksgiving. I regard gratitude as the prime virtue of mankind and when I achieve satisfaction at the easel (it may be only a single brush stroke) I feel called upon to express silently within my own mind this feeling of gratitude.

Once upon a time when I had spent my inheritance, I became dangerously despondent and as an itinerant sign painter I felt the melancholy of loneliness. In church a minister said something that changed all that. He said, "The providence of God is our inheritance," and it seemed he spoke directly to me. I had taken the word *providence* as it was meant and I realized I still had my inheritance, the *provide-ance* of God, which I'd never squander.

Since then, whenever I built a house I carved that phrase on my mantle. As a reminder, it is even lettered on my easel. I've had a lot to be thankful for and it's good to be reminded.

Here's Looking at Me

This all too scant autobiographical rambling would be completely insufficient without examples of my having lived. As much as looking at my own work is as discomforting as meeting an ex-wife, and seeing myself in the mirror is equally disturbing, nevertheless I present a small gallery of my work herewith, a brochure commemorating my eighty years.

Sophocles said, "One must wait until evening to see how splendid the day has been," but having lived my life as if each minute would be my last, I have savored and enjoyed them all. As each chapter is in some way a recollection of the writer and each painting is a part of the artist, perhaps my paintings speak for me. I have waited until evening and now accept my day as having been splendid.

THE·PROVIDENCE·OF·GOD·IS·MY·INHERITANCE·

Covered Bridge

My first covered bridge sketch, this rendition was done many years ago on the back of a restaurant menu in recollection of the Lovejoy Bridge over the Ellis River in Maine. Research told me this bridge was built in 1866 at a cost of $743.47. I liked that Maine exactness and put a price on the picture at the same amount, but my gallery manager had no sense of humor and listed it at $750.00. "That's more than the bridge cost," he said.

When I moved to New England in 1940, I was impressed by its long cracker-boxlike red tobacco barns and started painting them. They seemed to sell while the paint was wet and I asked my gallery manager why people so liked tobacco barns. "We thought they were covered bridges!" he explained. "Why not start really doing covered bridges?" I thought that was a good idea and I should begin researching. I always learned a subject by writing a book about it and as far as I know, I wrote the first book about American covered bridges. Since then I probably have painted as many as there are in the country. It was an exciting period in my life, which afforded me a fine consciousness of Americana.

The legends of Washington having crossed certain covered bridges are untrue, for he never even saw one; the first American covered bridge was built over the Schuylkill River in 1805. Vermont the "covered bridge state" is really fifth in line, Pennsylvania being first, Ohio second, Indiana third, and Oregon fourth. There are dozens of covered bridge clubs with monthly magazines or papers, so my gallery manager (long dead now) was right in his business acumen, but my interest in covered bridges has since waned and I cringe when I see one of my many versions.

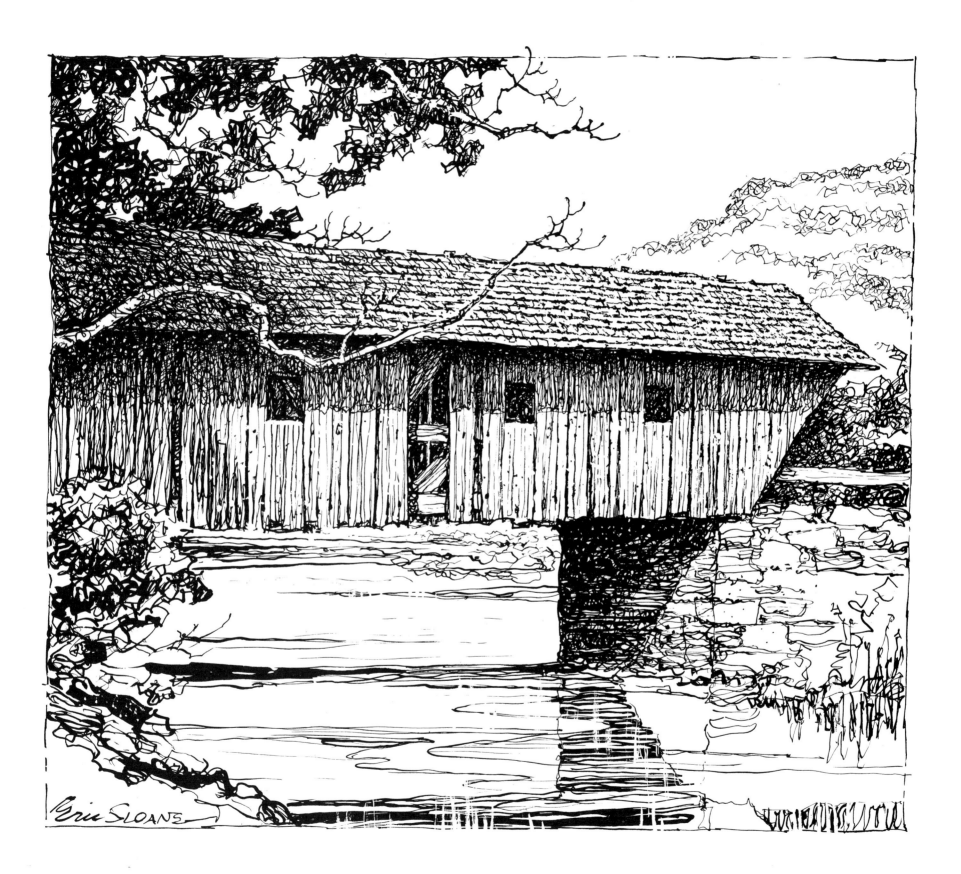

Black and White

It might seem strange that a painter admits reverence for black and white, but I have always contended that the simplest and most intellectual of the arts is the black line on a white background. No other medium can better recall the diorama of memory than the simple line drawing.

As you read these lines you are experiencing communication by black and white just as you do with everything you read, newspapers, even the Bible; you learn and write letters in monochrome. Up until recently all newspapers and magazines were confined to black and white. White is not always blankness; it can portray snow, sky, vastness, or coldness as the artist so wishes.

Monochrome allows the beholder to imagine color; less a spectator, he becomes artist and part of the picture. For example, consider the monochrome sketch opposite. You sense color that is not there; it might be green foliage or autumnal gold and yellow—it is all in your mind, for there is no color there. You have become the artist!

A few years ago I was inspired to dedicate a book to monochrome art and called it *Recollection in Black and White*. Perhaps my argument was not strong enough, for it was no best seller. Perhaps we have become color-dependent and psychedelically hallucinated. Perhaps we shall return to an appreciation of monochrome some day. Meanwhile color television is tops but, spoiled, I shall spend the rest of my life with my paints, devoted to color.

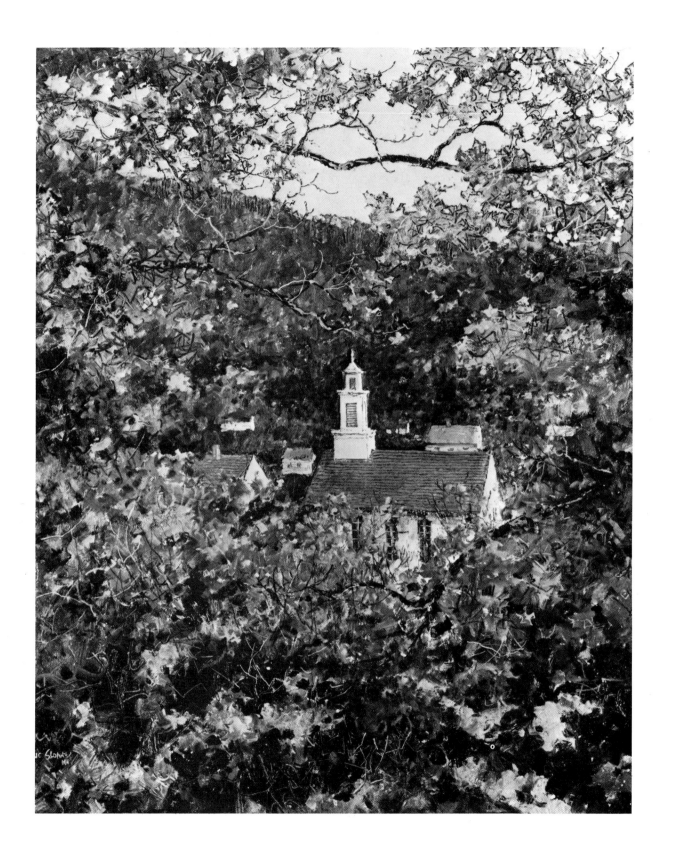

Diamonds in the Sky

The sensitivity of the camera's eye can be focused to almost unlimited presentations but, like an ethereal dream, the mood of flight through moonlit clouds must remain only for the memory of the beholder. Or possibly for the painter who paints from memory alone, as the cloud painter must do.

Cumulus clouds are usually creations of daytime thermals which deteriorate and return to the atmosphere when the heat of day leaves the earth and the sky yields to the cool of night. Only once have I flown through fields of cumulus clouds during a full moon and I've tried many times to recreate that experience. This example, a large skyscape (4′ by 4′) with stars to further the illusion of night, I titled "Diamonds in the Sky." My wife who is quick to detect triteness or excessive sentimentality, chided me. "That," she said, "is pretty corny. You might as well go whole hog and implant real diamonds in your painting."

Always aware of the talents of my severest critic, I did just that. Boring holes through the Masonite and reducing my bank savings considerably, I bought real diamonds and glued them in place. But not realizing the sparkle of gems depends upon light from the rear, my "stars" were hopelessly dull. White paint was better. So I removed them, patched the Masonite, and painted the stars back in. The punch line of this tale is that in time I sold the diamonds and made more money than the actual worth of the painting.

The painting still shows scars of my adventure, and I regard "Diamonds in the Sky" a piece of work haunted by laughs and lessons as well as an unforgettable flight through a cloud-studded night.

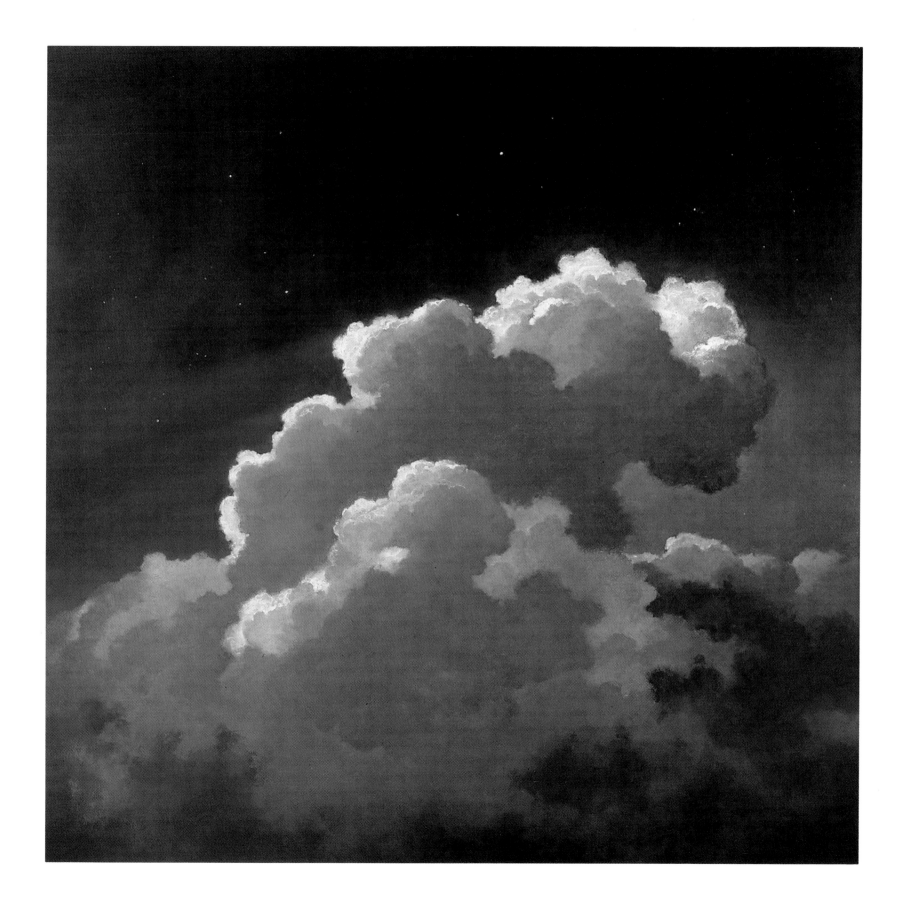

Sickle and Bucket

I have always regarded the early American sickle as being unique. Although the reaping sickle shown here might have been made in New England, the South, or any of the states, the design itself was always identical. The curve was so unique, so beautifully symmetrical that an artist now finds it nearly impossible to reproduce. How so many farmers in so many places happened to make their sickles in such a delicate and precise a manner seems a mystery. When I painted this picture, I found it necessary to use an actual sickle and trace its curve before I was satisfied.

The European sickle is quite different and when I did a painting of American and Russian sickles hanging together for my show in Moscow, I found an interesting cultural style of difference between the two.

Few things are really American, even the hot dog, apple pie, or ice cream. The rocking chair that was supposed to have been invented by Benjamin Franklin, was actually copied from a Dutch cradle chair. But the sickle and maple sugar (which was introduced to the white man by the American Indian) seemed to create the perfect symbol of our nation. I found the small maple sugar bucket and sickle hanging side by side in a Vermont barn, and they caught my eye as a meaningful still life symbolizing early America.

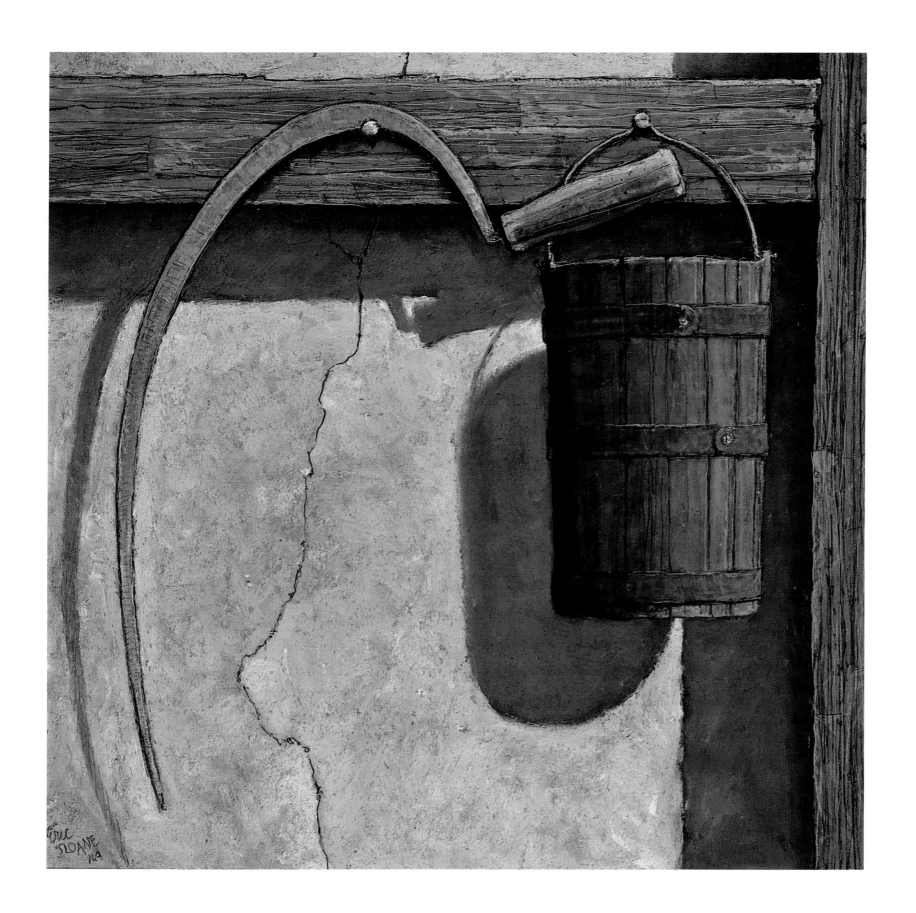

Autumn

My love affair with New England has been no happenstance: I feel certain that no landscape is blessed with greater color during the fall. An annual affair that started many years ago on my lawn to raise money for the Warren Fire Department and a clock for the Warren church, is now an established New England festival; I chose October the tenth as the date when the trees give their best performance and people arrive from all over the nation to enjoy the color.

There is something mystic about Indian Summer, that brief period after the first frost when summer magic haunts the countryside, spring frogs are fooled into welcoming a mock summer, and a blue haze settles over the hills.

The moral character of man may be likened to the autumn scene: leaves falling like our years, the sun growing colder like our affections, a time for harvest and reflection, of preparing for the eventual winter of old age, a season of melancholy and sadness mixed with satisfaction and the joy of having lived.

The ruins of ancient barns and farm monuments to early American life always seem most poignant in an autumn background and this small stone barn with its bevelly jog-wagon shed was a fine example. I happened across it while hiking during October. The fence rails were remnants of the forest reaped before the blight over half a century ago and as I walked inside on the hay-strewn floor there was an odor of some forgotten harvest of the past. Not an architectural rendering, I have tried to paint a mood, a memory bordering upon nostalgia, the richness and benefits of autumn whether experienced by nature or mankind.

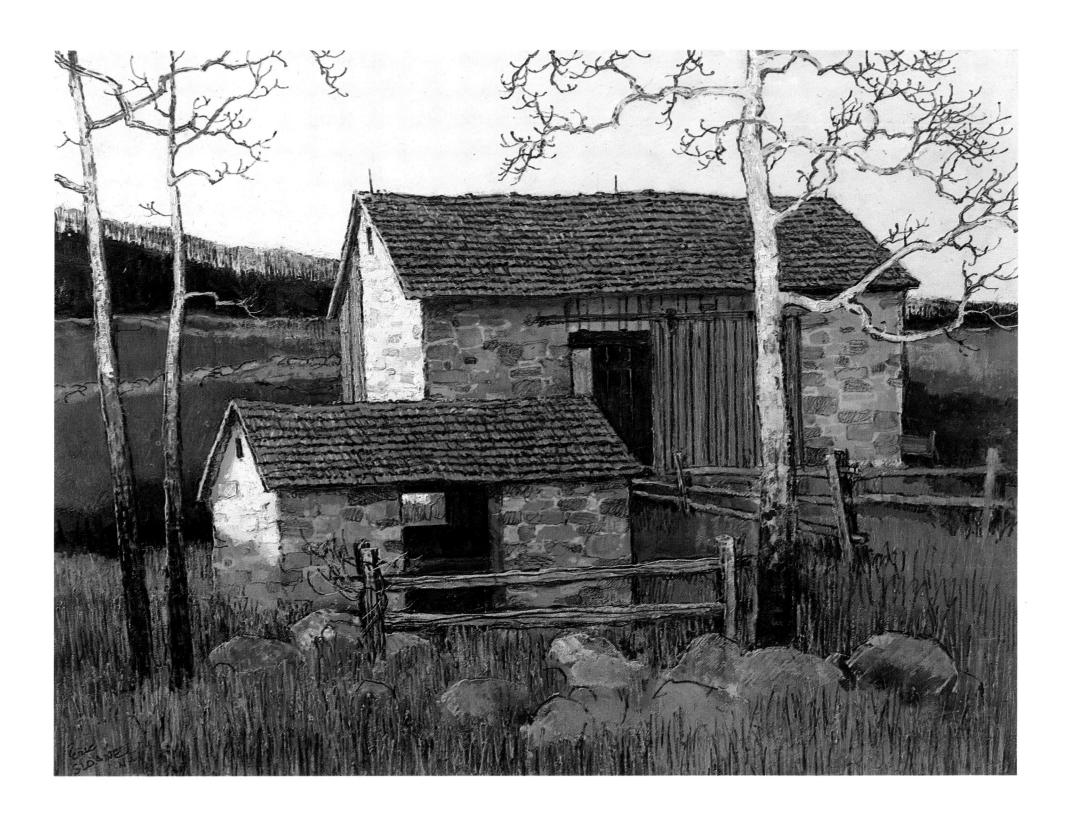

The Ancient Plow

Nowadays you see sculpture made from boilers and pipes and all the parts of modern-day scrap iron. New York's Museum of Modern Art exhibited an old bicycle wheel and a men's urinal from a garbage pile: I suppose it is modern art because art is supposed to exemplify its era and our time happens to be one of waste and bad taste. But on my living room table I have a real piece of art, a sculpture made by an anonymous American who pioneered the American way and thereby hand-crafted a work of art worthy of being in any museum. It is a plow.

I presume I am the only boy on the block with a plow on his living room table. More than a conversation piece, the patina of aged oak, the curve of the hand-forged plowshare and the symphony of the plow beam has afforded me countless hours of pleasure as I behold pure artistic folk art.

The farmstead that I bought in Warren, Connecticut had a barn full of abandoned farm machinery. Most of it was rusted and broken, but one piece was neither rusted nor broken. It was a plow made entirely by the original farm owner during the early 1700s. Leather washers from cowhide, four kinds of wood (each with a purpose) cut, dried, and fashioned with handmade tools from the nearby forest, and an iron plowshare made from bog iron found on the premises, are the materials for my work of art.

An old Shaker saying has it that "God invented the circle, religion invented the triangle, and man invented the square." I find that the symphony of lines called a plow is a design among man's finest achievements.

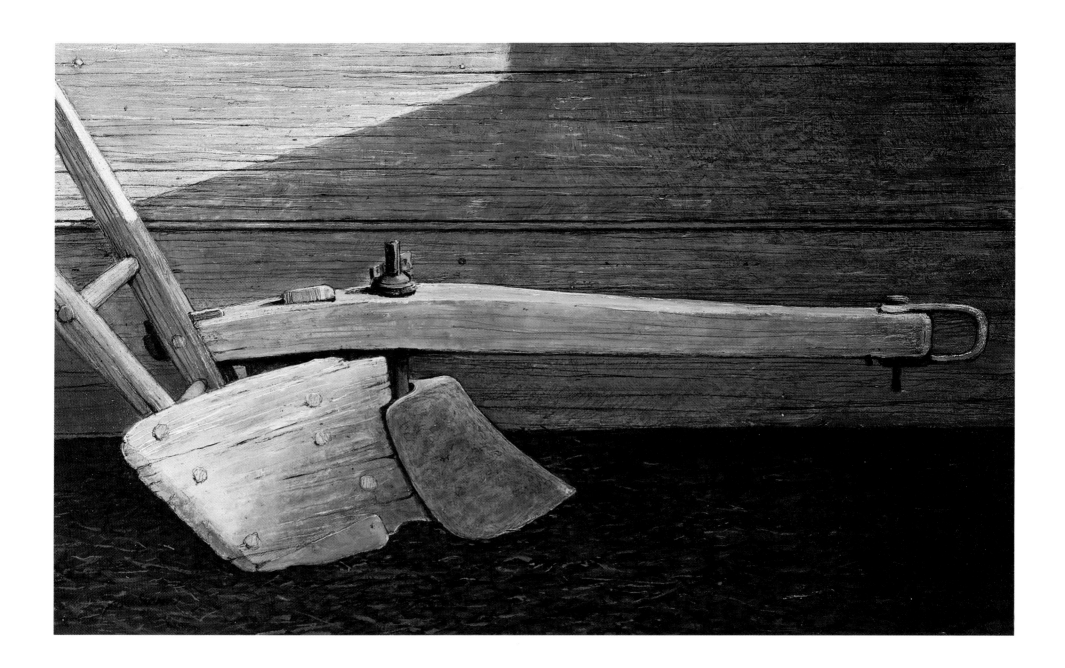

January Sunrise

When this painting sold, the gallery had it titled *January Sunset*. When I reprimanded them for mistitling it, they wrote back saying, "Sunset or sunrise—who would know the difference? Both look the same!" The answer was that *I'd* know the difference. Sunset clouds are usually cumulus or lumpy, a product of rising thermals from heated ground while sunrise clouds are flat stratus (as in my painting), the result of cold night air being pushed downward by the inversion of upper air heated by the rising sun.

When first I decided to make the sky a life study and studied to learn the anatomy of clouds and weather, I spent almost a year painting nothing but cloudforms. It baffled friends who inquired, "Just plain clouds? Who would buy such paintings?" That sold me all the more on my project because as crazy as the idea seemed, at least I'd have no competition. No other painter would be so stupid as to paint just clouds.

I still believe the panorama of weather offers a beauty that most people look at but do not really see, and that the sky, instead of being mere backdrop to the daily scene, can be a major symphony in itself, a much overlooked subject.

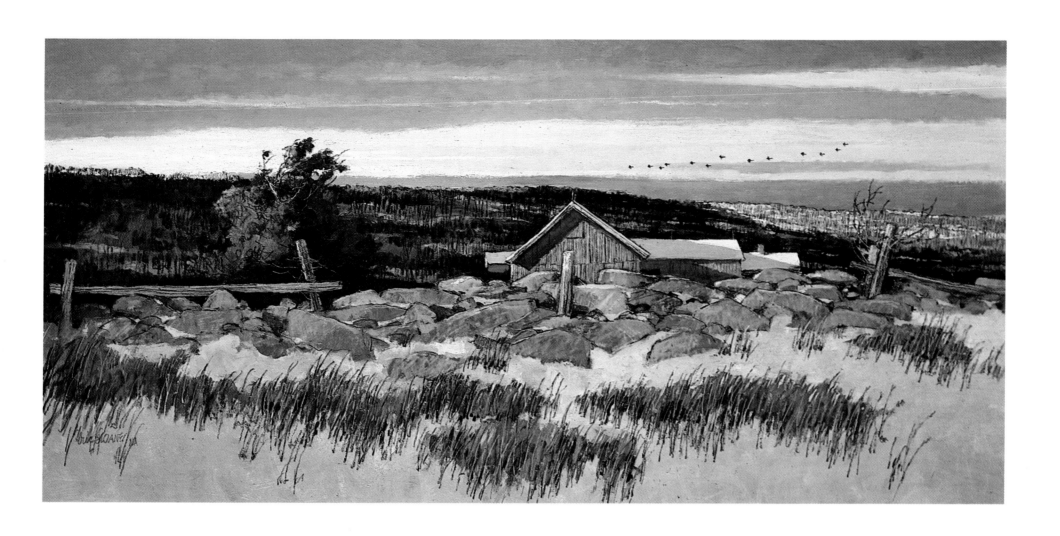

Autumn Mosaic

There is always some communicative expression of an artist that seems to appeal only to the painter himself; always a picture or sketch that means most to him and to no one else. Here is an example, something that will probably never sell, just a few dabs of color done in a few minutes, a brief conversation with myself.

The mood of autumn, the monotone texture of brown with an intrusion of bare branches, speaks of a melancholy season that some would rather forget. I suppose I kept this sketch and framed it for myself; no one would buy it anyway, I reasoned.

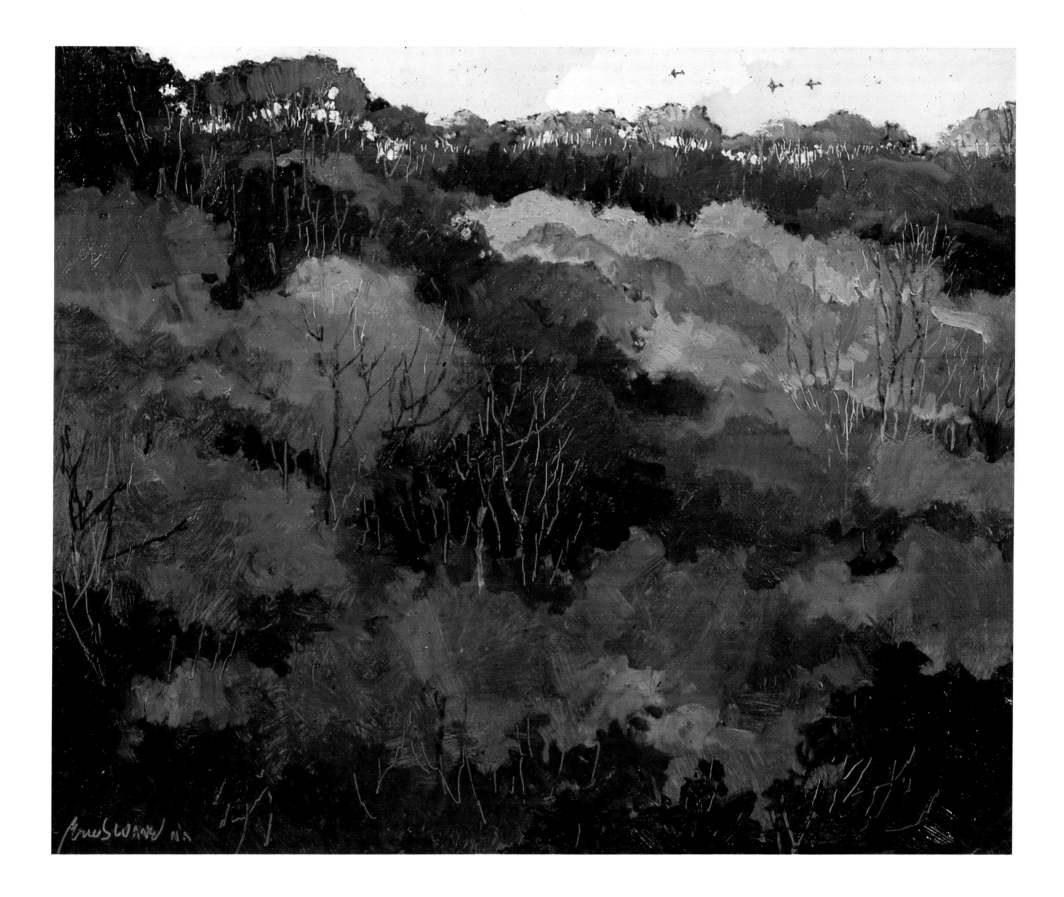

Pennsylvania Stone

Wandering in Pennsylvania during a late summer day, I found these stone buildings worth remembering and later did this oil sketch for *I Remember America*. I also recalled how I sought refuge in the big dank barn from a sudden storm and, though the building had lightning rods on its roof, there was still a load of very dry hay in the loft. My meteorological knowledge that barns often attract lightning because of the static electricity accumulated in old hay, led me to scamper into the rain and sit the storm out within the springhouse in the foreground. I enjoy watching the heavenly fireworks but have the greatest respect for lightning.

Springhouses were often the first buildings erected on old farmsteads. They are also the last to disappear after the ancient barns and farmhouses decay and fall. The springhouse is worth separate study, a suitable subject for an Americana book; I suppose I have painted over a hundred of them. I've never seen one gone dry, all of them having the same crystal-clear water running through cooling vats exactly as they did over two centuries ago.

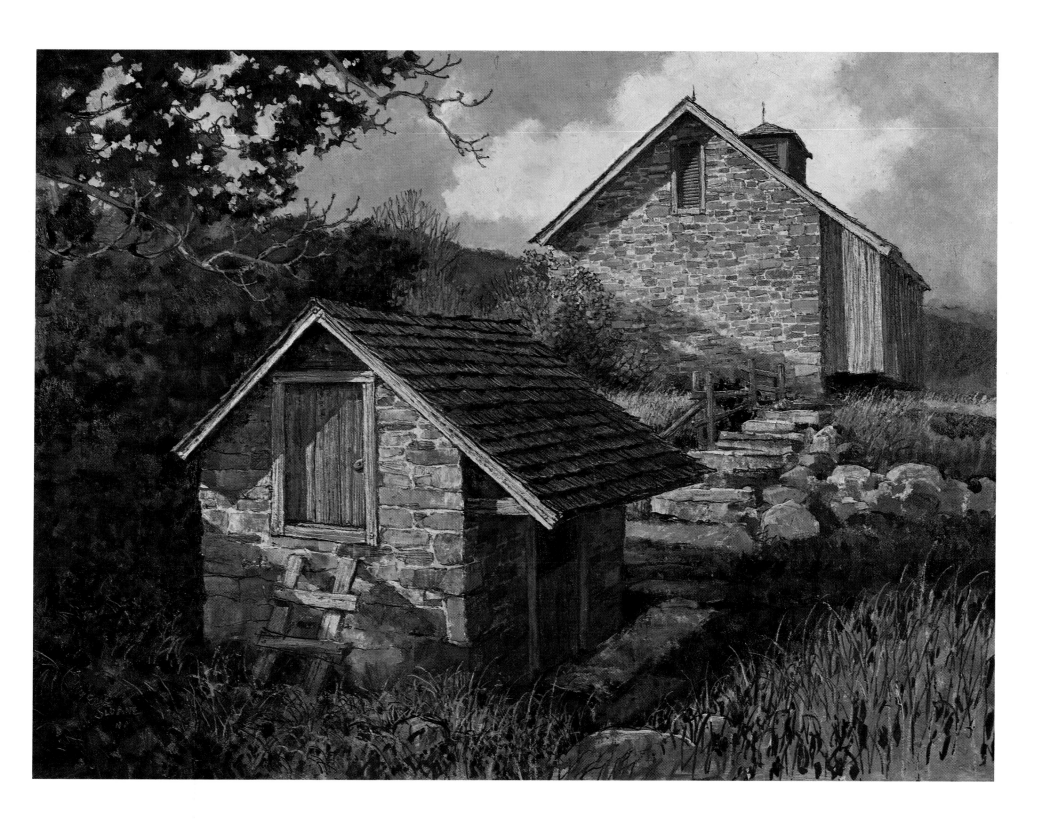

More Than a Place to Eat and Sleep In

There is a subtle aesthetic difference between the houses of yesterday and what we build now. Architects may try to reproduce early American design but when you motor along an old road at dusk you can pick out the ancient houses a mile away by their silhouettes. This colonial shape is the Hoxie House in Sandwich, Massachusetts. The steep roof was originally designed for thatching; the additions needed less pitch for weather protection.

Attics used to be important rooms for drying herbs and corn, for weaving, meat smoking, and general storage; nowadays attics usually have insufficient head room for walking. Builders today frame houses with puny pine two-by-fours (which of course aren't two-by-fours at all) and houses are built without the hardwood eight-by-eight beams of yesterday. Houses were once built for your children's children but now you will seldom (if ever) hear of one person living in the same house for a lifetime. I can count thirty-one houses and apartments having been my abodes to date!

I have discovered that the main difference between the old and new is that builders once started with a shape and then divided that shape into rooms: builders now start with an arrangement of rooms and then cover that conglomeration with a roof, producing bastard shapes.

As I type, I can glance upward at broadaxed beams over a foot square, weathered barn siding for a ceiling, and wooden pegs that welded it together into a frame that can withstand hurricanes. The twenty tons of oak from barns in New York State were sent to a New Hampshire framer to be fashioned into my house and then trucked back to Connecticut and pegged together. The result is more than a house; it is a constant symphony for all seasons, a delight to behold and a monument of Americana, more than a place to eat and sleep in.

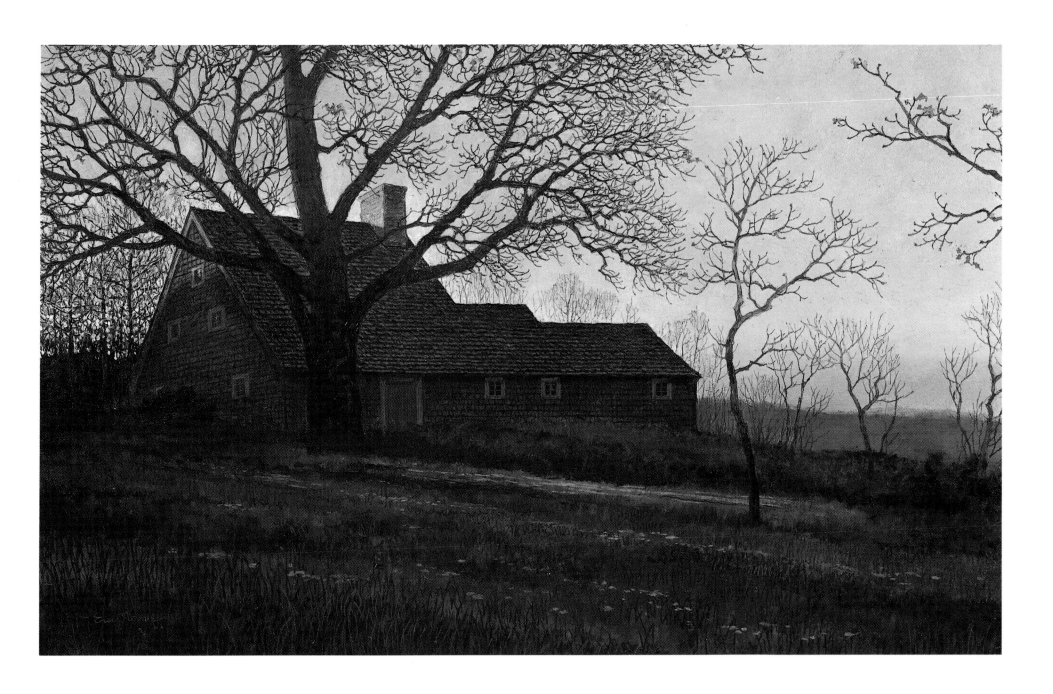

The Open Door

Doors have been a fascination to me, shutting me in from the outside world, opening to freedom, symbolizing both safety and escape, often identifying the owner's character. When building a home, the first thing I have designed has always been the front door.

The panels in early American doors resembled a cross over an open book (a Bible) or a plain cross to "shut out the devil." In Mexico a man may be without shoes but his sombrero should be of fine quality; likewise his house might be without furniture but his door rich and picturesque. Until writing this page, I had not realized that my worktable, kitchen table, living room table, and studio table had all once been doors. They have afforded me a richness and a certain aura that a store-bought table would have failed to present. I have often found some small ancient door worthy of being regarded a work of art and have hung it on my wall as pure decoration.

The painting shown here is not a picture of a barn interior with an open door. Instead I have tried to capture a mood of rural spring: the plow has been readied and the door that had shut out winter has been opened to the sun. The stalls are still dark and musty but the livestock are somewhere outside. If I have been successful, all the angles of shadow have pointed outside to the subject of spring, which you cannot see, but the mind's eye feels.

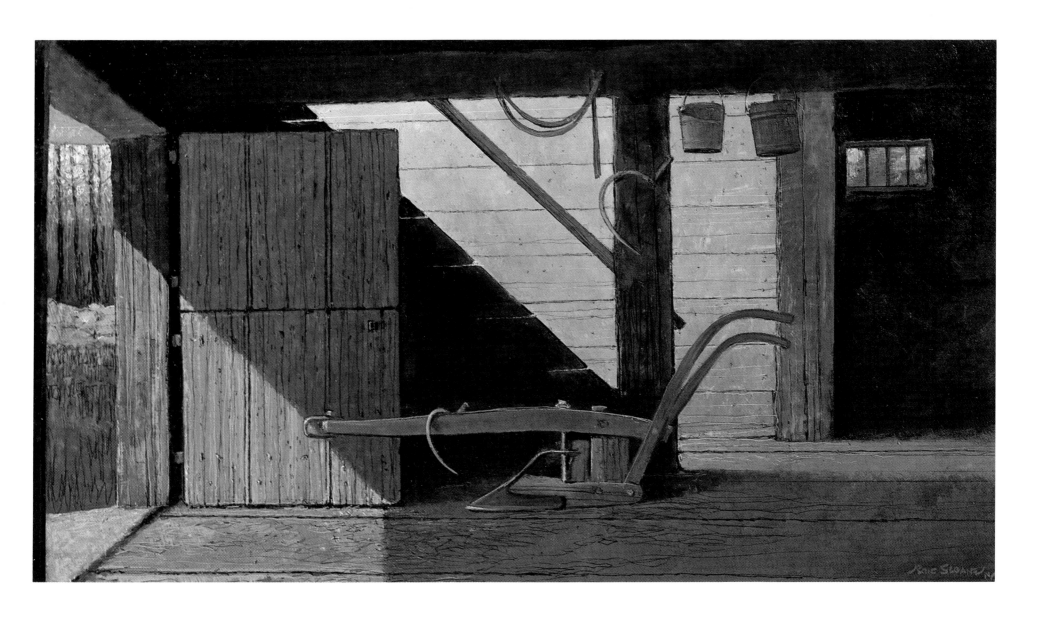

Pennsylvania Stone

New England is where "stone is grown" but the only thing they did with it was pile it into fences; there are almost no buildings there made of stone. But in Pennsylvania, where German peasants chose to simulate European castles and cathedrals, stone was chosen as their major building material. If you see a stone barn, you may be sure you are in Pennsylvania. In 1753 Lewis Evans wrote, "It is pretty to behold our backsettlements where barns are as large as palaces while the owners live in log huts; a sign of thrifty farming." But with the arrival of the nineteenth century and the success of American farming, even farmhouses were built of stone. If I were not so stubborn a New Englander, I am sure I would have chosen the Pennsylvania scene as my home and built a house of stone.

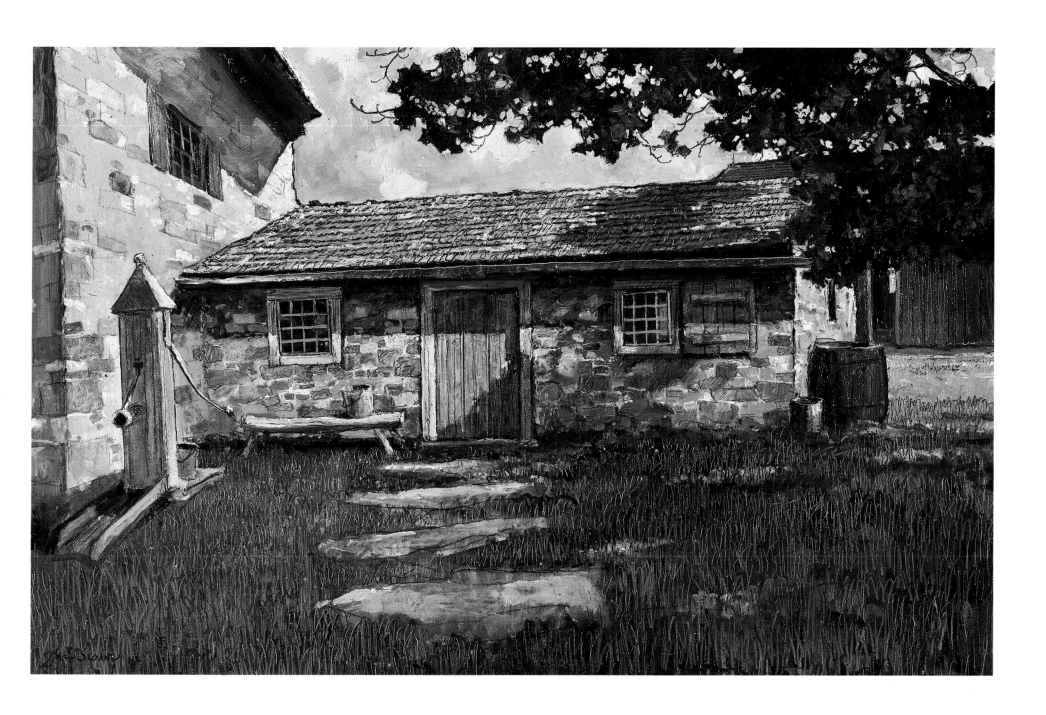

August Thunderhead

Evening thunderheads are rare because most thermal storms disappear with the end of daytime heat; during August when warmth and dampness create lofty cumulo-nimbus clouds, they persist into late afternoon like the one shown here.

So many painters, when attempting a sky, will reach for blue; but it has been my contention that the painter who can paint a sky with the least blue, or no blue at all, is an artist indeed. Cerulean seemed the least offensive to me until I discovered *manganese blue*. It was about half a century ago that on a Sunday (when all New York stores were closed except tiny newspaper shops) I ran out of cerulean blue for a deadline illustration. The little shop around the corner sold grade school supplies and lo, there I found a tube of cerulean blue for only ten cents! But it had been on the shelf for so many years that it had oxidized and blackened into a completely different paint, like nothing I'd seen before. It had become the first "manganese blue," which is now patented, registered, and the only blue of my palette.

I consider black not a color, using Payne's gray as a substitute, but should a painter wish pure black, Alizarin red and Prussian blue make a black much blacker than black.

The sky is full of color but when looking aloft for it, intense sunlight causes the eye to reject it. I devised a method of seeing sky color by painting a pane of glass black on the underside and observing the sky's reflection in the "black glass," lessening the glare and bringing sky color to the sight.

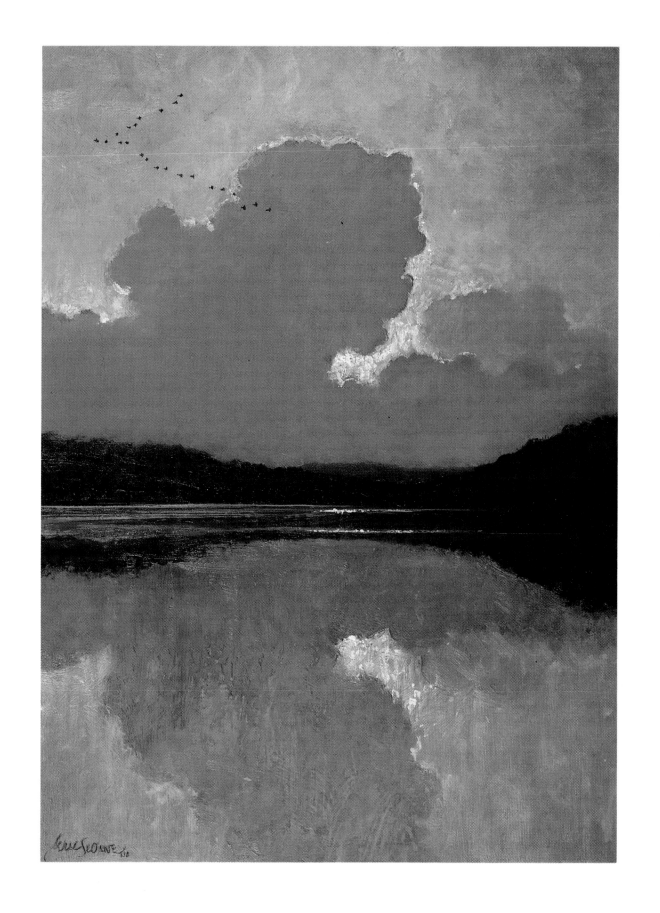

Trees in Winter

My small museum in Kent, Connecticut was built to commemorate the early American's reverence for trees and wood. From cradle to coffin, all furniture and necessities of life came from the forest. Houses, nuts, fruit, paint, medicines, tools, farm implements, sugar, barrels, baskets, fires for cooking and heating, everything was made of wood. The pioneers came to America not as much from religious persecution as from the fact that Europe and England had run out of wood. Trees were the wealth of the New World. My paintings and writings have largely been conversations about trees and wood, for my conviction that art should have purpose has given me a lasting satisfaction.

When I wrote *A Reverence for Wood*, I started each chapter with an appropriate poem. But there was a deadline for publication and I had run out of "appropriate poems": my thesaurus and books of quotations had nothing to offer about the subject of firewood. So, tongue in cheek, I used my true name (Everard Hinrichs) and wrote my own poem.

The heft and feel of a well-worn handle,
The sight of shavings that curl from the blade;
The logs in the woodpile, the sentiment of huge
 beams in an old-fashioned house;
The smell of fresh-cut timber and the pungent fra-
 grance of burning leaves;
The crackle of kindling and the hiss of burning logs.
Abundant to all the needs of man, how poor the
 world would be
Without wood.

—Everard Hinrichs

Several letters followed inquiring about "Hinrichs" and where one might find more of his works; of course such inquiries were unanswered. But when one institution chose my poem for winning a prize, I confessed. My reverence for wood had produced at least one poem and I was considered a poet.

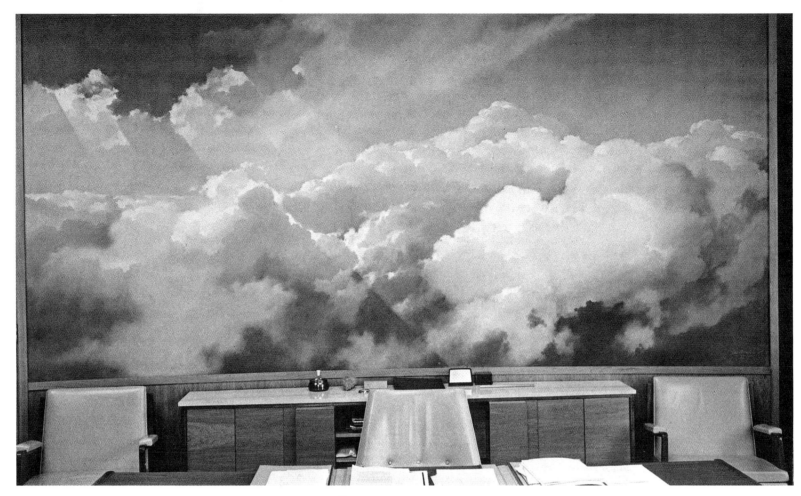

Three Hours

No painter should admit such a thing but at my age I don't give a damn: the best work I do is often done quickly. Sometimes in three hours. Franklin said, "Anything that takes over three hours becomes boring." I think he was referring to dinner time but nowadays plays and concerts, movies and a lot of other human activities seem timed to that average.

I find that it takes about three hours for me to shape out a painting composition at which point I like to leave it for drying and continuing the next day. Sometimes the three hours are enough, like the office mural above which I did many years ago for the then new Morton Salt building in Chicago. I started at nine in the morning and at noon had the good sense to realize further work would add nothing and so I finished at noon. When the president arrived at one o'clock to "watch me work" I was on a plane heading back home.

The painting opposite is the one that took me "two years and three hours to do", one of the rare paintings that has satisfied me. After all, art isn't done on an hourly wage.

November

The crispness of fall, the silence of still trees, and the solidity of stone creates an aura that the camera cannot capture but the painter is privileged to recite. Trees during summer display their clothing of leaves: their bodies come to life when they disrobe. The green of summer makes all trees look alike but in November an apple tree admits to being an apple tree and is proud to confess it.

This scene was painted from memory—not a picture of a farm but the recollection of a mood. It happened in Bucks County during November when I spotted the abandoned stone barn. It was an invitation worth accepting and I spent a memorable hour there. The well house was as usable as it was two centuries ago, and the red paint on the overhang of the stone barn still matched the color of that many autumns. I wasn't sure if autumn was a setting for the picture or the picture was a setting for autumn.

When the painting of my experience was done and it sold to a printmaker, it became a favorite among print collectors. I am sure that buyers were not purchasing a wall decoration but collecting a memory, a reverence for some personal autumn experience of their own.

I returned to that same area in Pennsylvania looking for that abandoned farm. It was during summer when I found the location. The tree was still there but the buildings were gone and several split-level "ranch houses" had been built in their place. I was glad to have captured the November of a part of Americana and a mood of a past.

Northeast.....

Just as I have always had a love affair with New England, my wife Mimi feels the same way about the Southwest. Our place in Santa Fe is accepted as hers and our place in Connecticut as mine. The two-thousand-and-five-hundred miles between Sloane households poses problems in duplication and matrimony but so far I have managed to average about a month in the East to a month in the West, with birthdays and holidays complicating that routine. We get along beautifully by telephone and mail, never getting together long enough to have a serious quarrel.

As opposite as the two places are geographically, there is a strange cultural aura pervading in both places which I find historically American in spirit.

My research finds that the difference between the early American and the man of today is a matter of *awareness*. The first pioneers were awake to the dangers and simple differences of the New World's Indians, sudden storms, diseases, wild animals, severe winters, droughts, and all the hardships of the great adventure. They were conscious of each moment, magnificently aware of life.

We today are lethargic, for so many things are done for us and so we are robbed of the joy and satisfaction of awareness. We switch on lights with no idea of the source, turn a faucet with no idea of where the water comes from. Our clothing might come from New Jersey or Taiwan and even the source of our food is of no particular concern. Few

Southwest

of us know why we are existing and the country with its politics has become too big and complicated for individual awareness. My life's work by writing and painting has been to reawaken the original American consciousness, that quality which created the United States and abounded in earlier days.

Strangely enough, perhaps because the Southwest is a newer experience and early Spanish and Indian moods still exist there, I find the land rich with awareness. Human attitude there has not yet been weakened and diluted by commerce. New Mexico is advertised as the "land of enchantment" but other parts of the United States really offer more enchantment to the eye and the Southwest's real mystique is more a mood of art and time. The Indian's respect for the land, even making his house from adobe bricks made from mud and straw, has been accepted as Southwestern architecture: his reverence for the sky has been transmitted as a major tourist enchantment. In the Southwest I actually feel the early American awareness as strongly as I do in New England, but when autumn comes, however, I am always eager to speed back to Connecticut. Then when I sit at my easel in the Northeast, I often find my mind drifting to the Southwest and start painting the Taos Indian scene; I could not conclude this mini-autobiographical account without some examples.

Taos Rainbow

My first glimpse of Taos in 1924 was a rainbow affair. A brilliant setting sun had heralded the end of a summer rain squall, lighting an adverse sky and producing an arc of major colors in the storm's remaining mist such as I'd never seen. I'd always seen rainbows strike the ground at a great distance, but this one seemed to enter the earth directly in that plaza of land dividing the two pueblo complexes. Actually it was marking a true "pot of gold" for me as it marked a special place on earth that I have since treasured in both writing and painting.

Once when I pointed at a rainbow to an Indian friend, he slapped my hand down, saying, "You must never point at a rainbow!" This superstition derives from an Indian legend, which regards the sky as Holy Father and the earth as Holy Mother. The rainbow was their symbol of Father Sky mating with Mother Earth; therefore, calling attention to that very private and sacred union would be an intrusion and bad taste. Indians now say that pointing to a rainbow is "bad luck"; what they really mean is "bad manners."

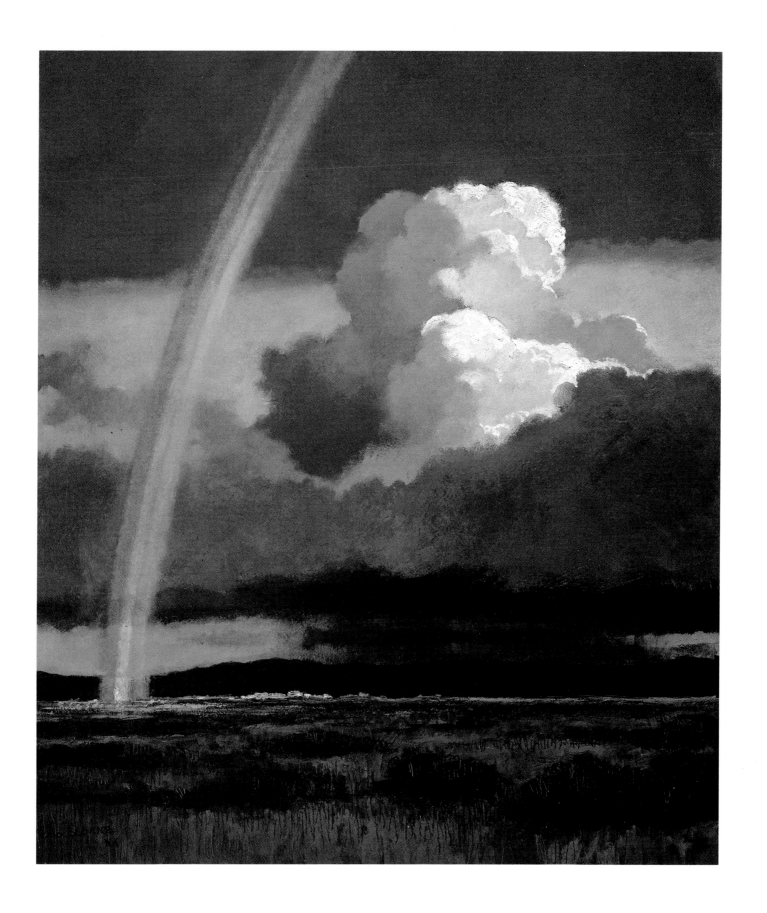

Rabbit Hunt

This scene depicts an ancient ceremony of the Taos Indians, when bow and arrow were used for hunting. On this day a group of braves rode on the outskirts of the pueblo (shown at the right, in the distance) hunting rabbits from horseback.

I once tried shooting an arrow from horseback without the slightest success, much to the amusement of my Indian friends. My bow (in 1924) had an eighty-pound pull and was not designed for the occasion; it needed the same number of hands I needed to stay on a horse and the result was a rude dismounting in the chamisa bushes.

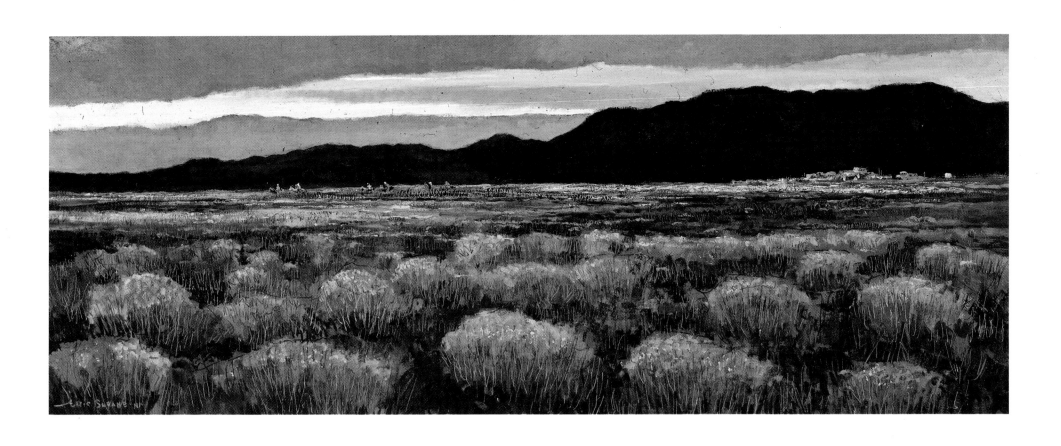

Taos Pueblo

Taos pueblo hasn't changed much in four centuries, certainly not at all since I was a boy guide for the tourists in 1924. That was the year I joined a group of Indian dancers with the idea of becoming agent for them. Trinidad Archuleto, the youngest dancer, lived in the uppermost compartment, as shown in the painting, and I often camped out where the blue door is, in the foreground. Juanito Luhan, the dance leader, lived where a light shines in the ground floor.

I remember making a hoop as a toy for Juanito's little nephew Bobby and how Juanito taught him to dance with the hoop instead of rolling it with a stick. Today the Taos hoop dance is famous and legend has it that the dance is centuries old. I can prove that untrue; I'll settle for sixty years.

The oval oven (called a *horno*) shown at the right is used for baking bread but one lady tourist exclaimed, "What a darling dog house!" I explained it was not a dog house and offered to prove it. But as I removed the wooden door, three puppies exited.

The Indian trudging toward the pueblo is carrying water: Taos Indians chose not to have electricity or city conveniences, and they still get their water from the crystal-clear stream fed from Blue Lake that nestles above in the Sangre de Cristos, exactly as they did when Coronado saw the pueblo in 1548.

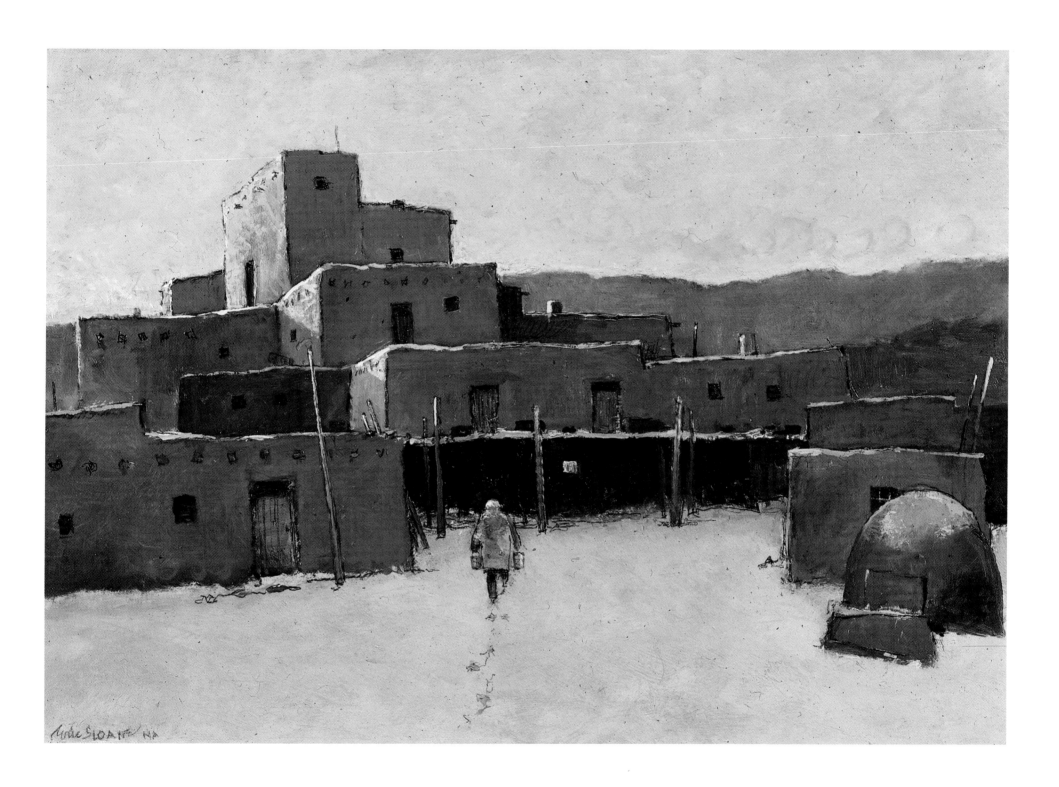

Sky City

The puebloes that nestle on top of southwestern mesas were originally built for protection. That still holds true because they are somewhat protected against tourists and Sunday painters, still isolated and nearly inaccessible except to those who are willing to walk and climb.

Sixty years ago while touring the base of this scene in my Model T Ford, I found a small cannon embedded in sand, its ornate muzzle protruding and glistening in the sun. Through trips across the country, and four marriages, I once gave the cannon to a Taos lawyer as part payment regarding a divorce, a transaction I regretted for years. My regret was miraculously answered and fulfilled recently when I found my long-lost cannon for sale at Fenn Gallery in Santa Fe. It is now the only souvenir of my introduction to the Southwest and a reminder of distressed times and perplexing situations not without an occasional chuckle.

The "City in the Sky" is draped atop a three-hundred-and-sixty-foot table of rock, blocks of terraced houses much the same color as the cliff itself. If this is not American architecture, I don't know what is, for here the first Americans and their culture thrived long before the English and Europeans arrived on the East Coast. There was no written declaration of independence among those first Americans of the Southwest but they practiced a religion and pattern of life we might well regard today.

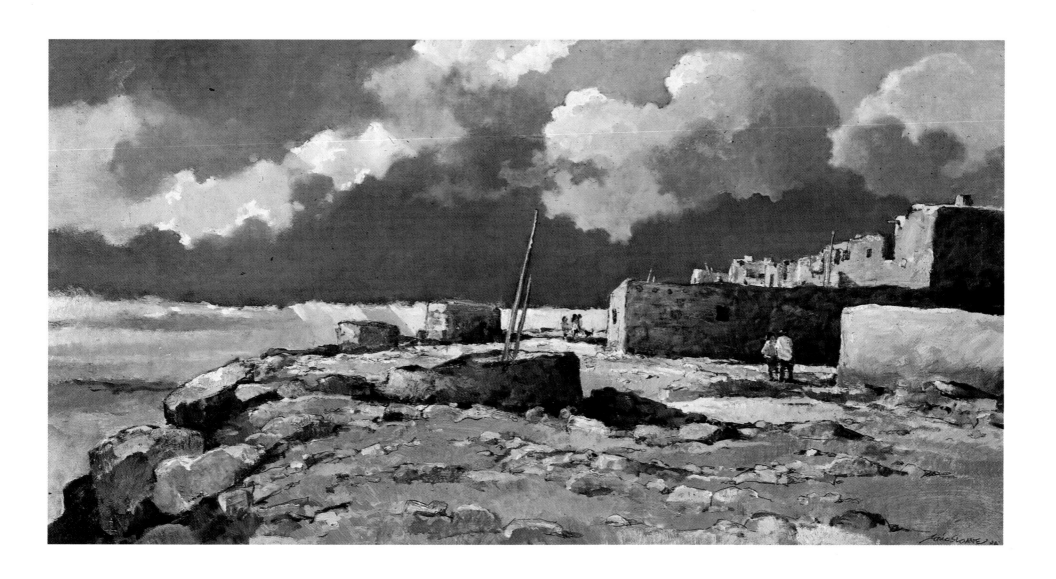

Taos Morada

I believe that a great picture is tested by half closing your eyes till you can hardly see it. At that point, if the composition is superb, you can see almost more than with your eyes wide open; unimportant parts miraculously disappear but the overall design looms clear. This painting is an example of my theory, for looking at it with nearly closed eyes you will see only squares, triangles, and sweeps of light and shadow surrounding the main theme of the cross.

The *morada* is the church or meeting house of New Mexico's Penitentes. This building still stands a short distance beyond the historic home of Taos's famed Mable Dodge Luhan. Seemingly empty, the adobe walls reflect the western sunset and reflect the customs of the nearly forgotten branch of early Catholicism. I suppose the habit of self-torture and imitations of Christ's crucifixion have been outlawed and discontinued, but scattered all over the Southwest are evidences of Penitente faith—windowless adobes, crosses on hilltops, whispers of secret meetings, and fifty-mile foot journeys through rain and snow to commemorate Easter and the agony of Christ.

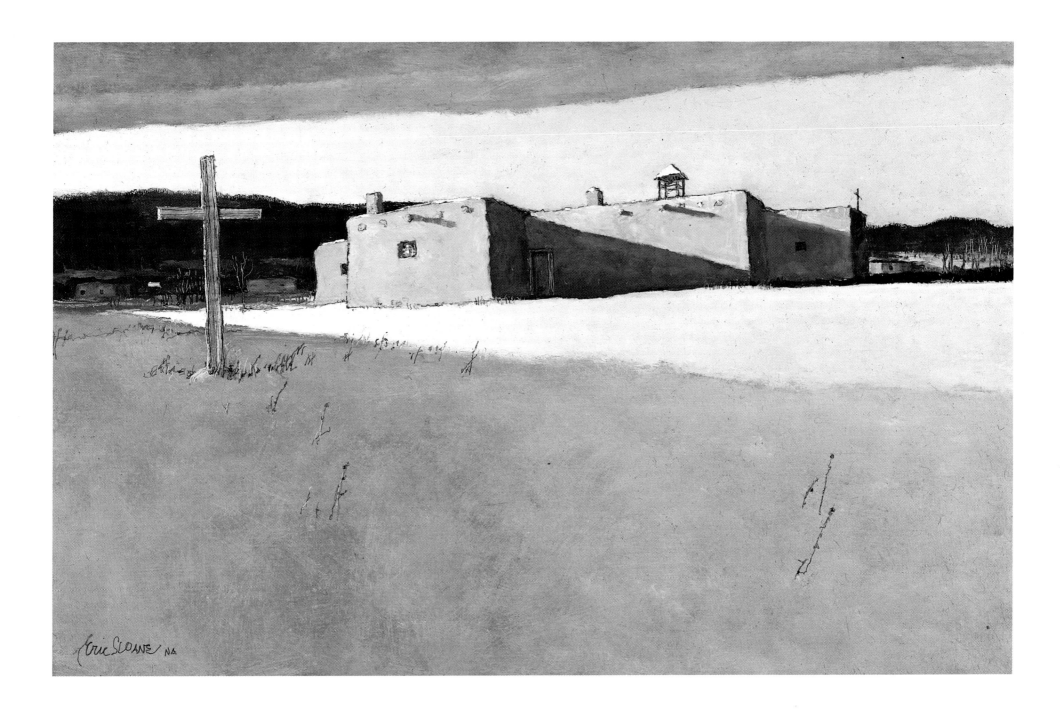

Prairie Schooners

I remember finding difficulty in portraying the immensity of clouds in a skyscape and solving that problem by adding the tiniest dot of an airplane. It didn't seem like fine art, yet such comparison emphasized the enormous mountain of cloud forms. Likewise, a snow-covered mountain could be painted to appear its proper size by adding a tiny skier. The rock formations shown here could appear to be about a hundred feet high until I added the covered wagon group below it. It was a trick that the Hudson River School excelled in, each landscape featuring people, cattle, or some familiar object to indicate, by comparison, the size of land formations.

The landscape painter is often reluctant to add figures in his work, sometimes because he doesn't excel in figures, and I sometimes wondered why I had this habit and for what reason. When word-artist Louis Nizer was chosen to give me a medal at the National Arts Club, I winced when he remarked, "Eric Sloane seldom if ever puts a figure in his paintings." But I felt relieved and pleased when he added, "But there is always someone in his paintings—it's *you!*"

Somehow or other, experiencing something dramatic is more emotional if you are alone. I feel that a scene is more eloquent when viewed by yourself, so it seems important for me to paint with an aloneness, making the beholder feel unaccompanied. Speaking of prayer, when one confers with God it is proper to be alone; speaking of art, the emotion experienced by viewing a painting is enhanced by the illusion of it being a personal and private communication. Such is my belief and such is my manner of painting.

I suppose an artist paints (or writes) according to his way of life, and I find peace and comfort in solitude. When I am alone I am protected against loneliness. Van Wyck Brooks, the dean of New England writers, told me that loneliness is an American bittersweet, and the New Englander finds loneliness a tolerable companion. I believe I have been painting as a New Englander for a New England audience, for the rambling melancholy of deserted farms and the stone fences of other days stirs emotion to my palette.

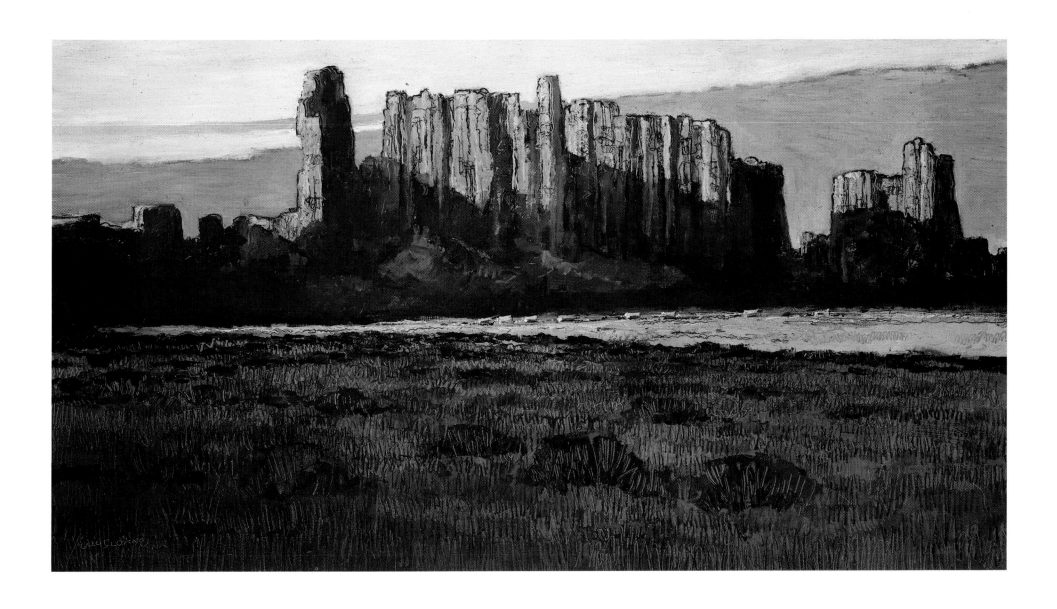

Taos Blue

One mystery of Taos puebloes has been the use of blue on its window frames and doors. Historians agree that blue is one color that cannot be created from local plant dyes, yet blue paint has been traditional in Taos puebloes since the early 1800s. I once asked an old Indian about this and his reply interested me. "I don't know," he said, "but my great grandfather used to call it sugar-blue." His remark started a spark of research that resulted in what I believe is the answer to the riddle.

Early American sweetening was first derived from maple syrup (a plentiful product of eastern forests), but when the pioneers went westward they brought with them imported cane sugar in cones wrapped with blue paper rich with indigo dye. New England housewives had long prized these indigo wrappings for dyeing cloth, and when venturing westward it was natural for them to include a supply for trading with Indians.

Pennsylvanians used milk and indigo for manufacturing paint, and many Conestoga wagons were painted with a pale turquoise blue the exact shade found on old Taos doors. It is interesting to consider the source of paint coming from sugar wrappings of covered wagon days, but I cannot think of a better explanation. The indigo and milk paint had a sturdy plastic quality that lasted for a century, and in the early 1900s Sherwin Williams Company established "Taos Blue" as a standard house-paint color.

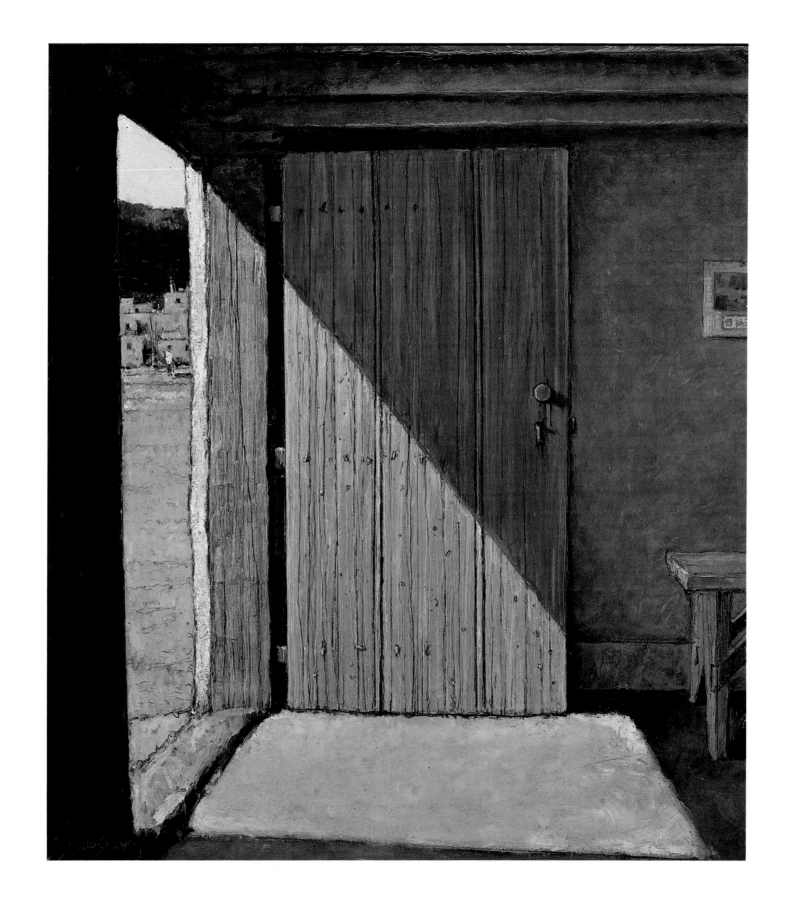

Sky Fingers

When Tony, the Indian husband of Mable Dodge Luhan, came from Taos to visit me in the East in the 1920s, he still wore his traditional Taos white sheet and deerskin moccasins. The Luhans always kept a New York City apartment at One Fifth Avenue and Tony found his annual visit and shopping tour at Altman's for fine-quality sheets a diversion from tribal complications and criticisms back at the pueblo.

As we motored to my father's place in the country, Tony called attention to the many white churches and tall spires. "You have many fingers pointing to Father Sky here," he said, "much like our kiva poles."

I'd often wondered why those ladders descending into the sacred kivas always extended ten to twenty feet skyward, serving no apparent purpose beyond the ladder steps. Only then did I realize that kiva ladder poles served as religious spires just like the white man's church steeple that pointed to heaven.

When I recently built my studio in Santa Fe, I fashioned it kiva-like, half buried in a hill. Warmer in winter and cooler in summer, I still had a north light window, and copying Indian custom I erected kiva poles to pay respect to Father Sky.

In the Southwest the terrain of Mother Earth hasn't changed in countless centuries but the panorama of sky changes each moment, as clouds are born from the atmosphere and dissolve back into invisibility like life and death. I find no part of geography more spiritual than the sky, and my kiva poles express just that.

my Kiva studio in Santa Fe.

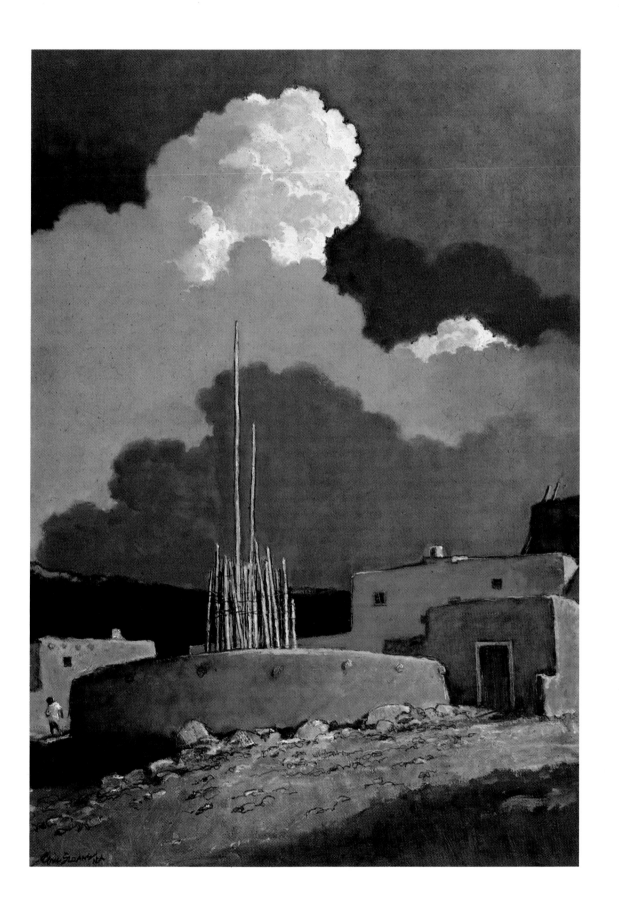

New Moon

A stone fence, lush grass, and the lace of summer foliage brings back to me over half a century of similar new moons that have enriched my life. I've seen many moon paintings but only of "full" and so-called "new moons" and I have often wondered why this is so: the phases of waxing and waning have been neglected. I always feel called upon to exclaim, "Have you seen the *full moon* tonight?" or "Look at the *new moon!*" Never to my remembrance have I called attention to a half-moon or an oblate moon.

I've done many farmhouse scenes at dusk and always enjoy adding a dim light in the kitchen-wing window; it brings a spark of life to an otherwise drab composition. So many times have I been motoring across miles of farmland and noticed a lonely light in some distant farmhouse. I was sure there was the comfort of a kitchen stove, a kerosene lamp that afforded light to read a Sears, Roebuck catalog to the song of a simmering pot of bubbling soup. Perhaps I was wrong in my imagination but the idea always gave me satisfaction and added some comfort to my lonely journey.

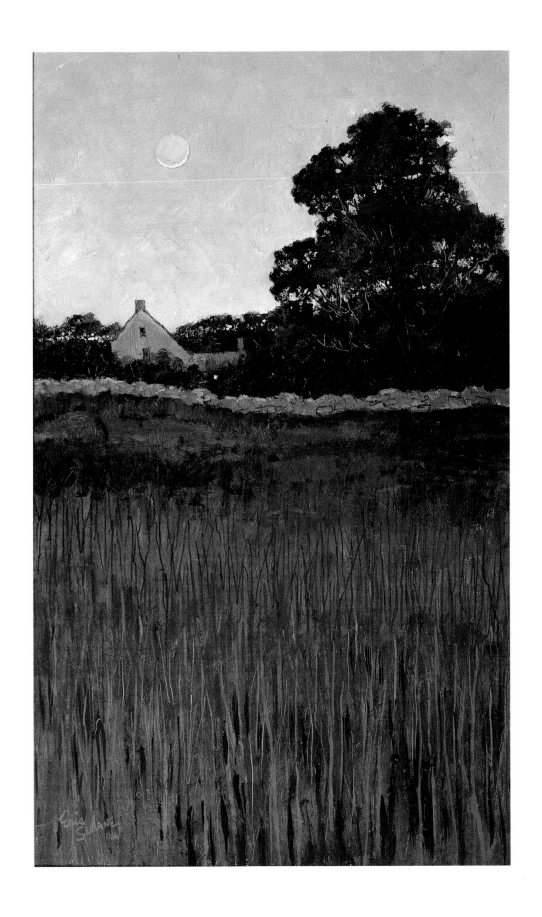

Bucks County Farm

This is a typical Pennsylvania stone bank barn, built into a bank of earth, with a wooden overhang to the south. The overhang offered shelter from rain for livestock, with its doors facing the sun, while the excavated north portion gave them warmth in the winter and coolness in summer.

Many variations of the bank barn evolved during the nineteenth century, all typical of Pennsylvania architecture and reminiscent of the time when the farmer was king in the American way of life and barns were the palaces of the New World.

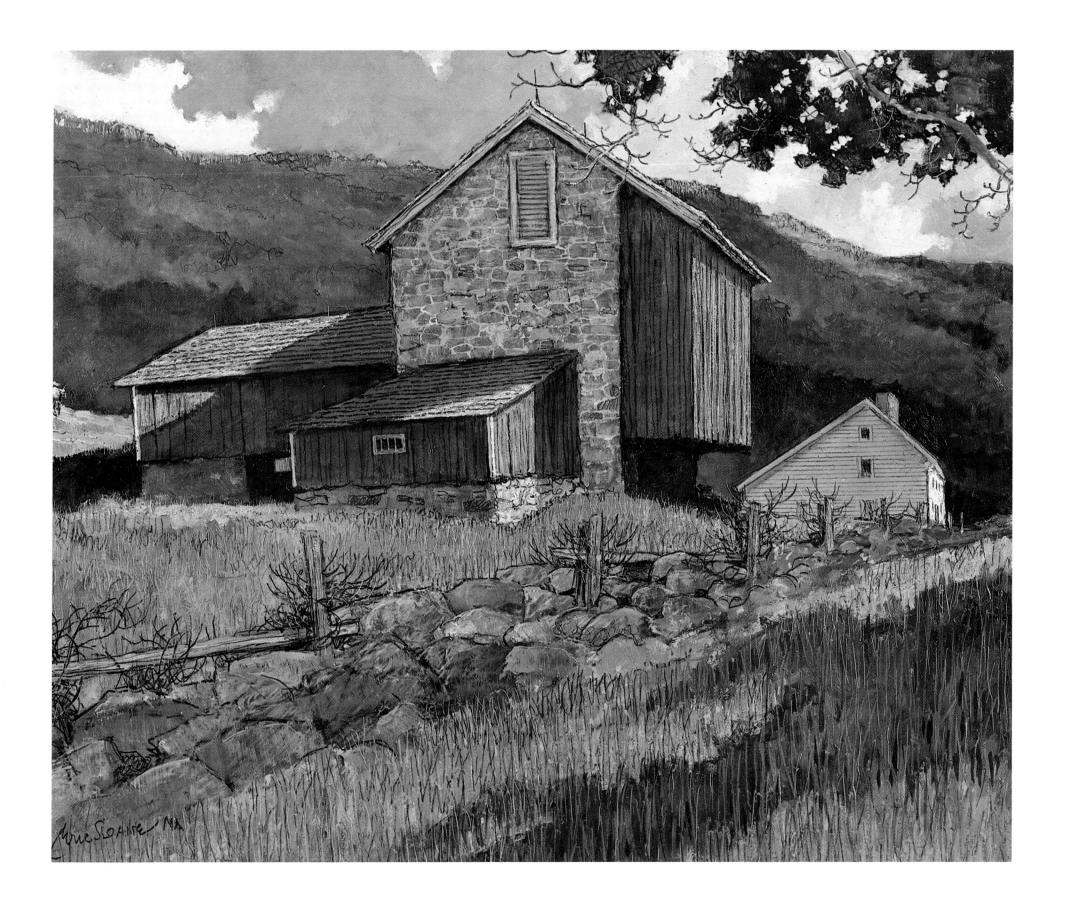

Bittersweet

If I were to imagine a plant that symbolizes the aura of New England winter and the ruggedness of rural farmlands, I would choose bittersweet. Growing out of rocky soil, climbing over stumps and dead wood, bittersweet's crimson and orange berries sing a lively song in the most barren landscape.

Bittersweet, to me, is more a description than a name, more a symbol than a plant. I confess to doing many versions, perhaps overdoing the subject. My studio and living rooms have always had sprigs of bittersweet here and there, and I shall never tire of it.

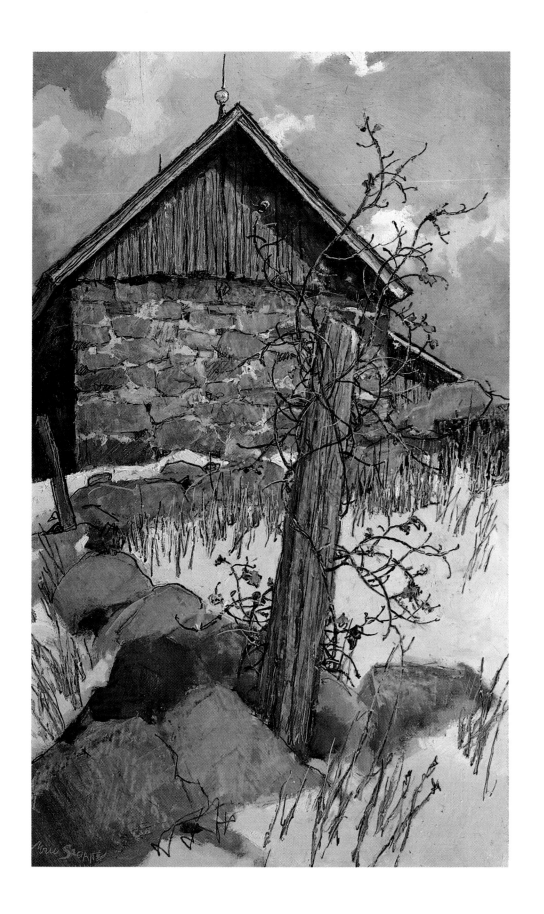

Brown Autumn

Brown is a neglected color. The dictionary says it is "any of a group of colors between red and yellow." Go into an art store and try to find a tube of brown paint: you'll find sienna, Van Dyck, madder, umber, and ochre but never just plain dark or light brown. It is the color of autumn and I like it. So I thought I'd give brown a special distinction and do a painting in shades of brown.

Of course I used tubes of sienna, Van Dyck, madder, umber, and ochre.

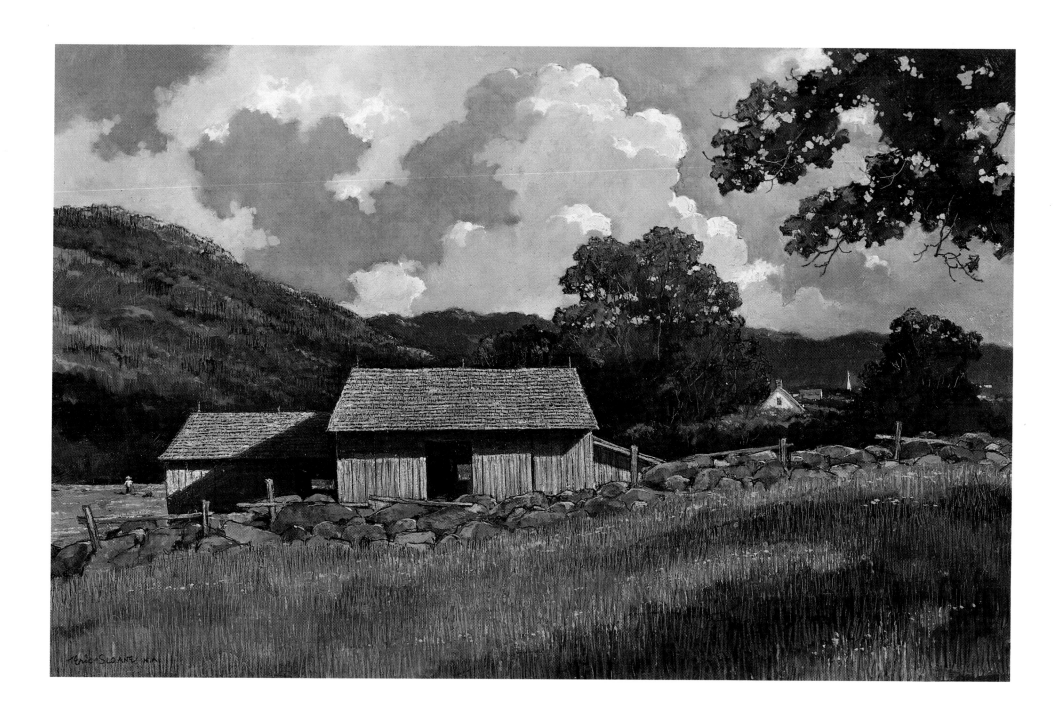

Yesterday

The twisting branches of the sycamore tree has always at some time or other been a subject for the painter of the American scene. Nearly always present in the Pennsylvania landscape, the sycamore was often hollow in structure, making the trunk ideal for carving into large barrels for grain. I have one sycamore barrel in my museum in Kent, Connecticut, about three feet in diameter.

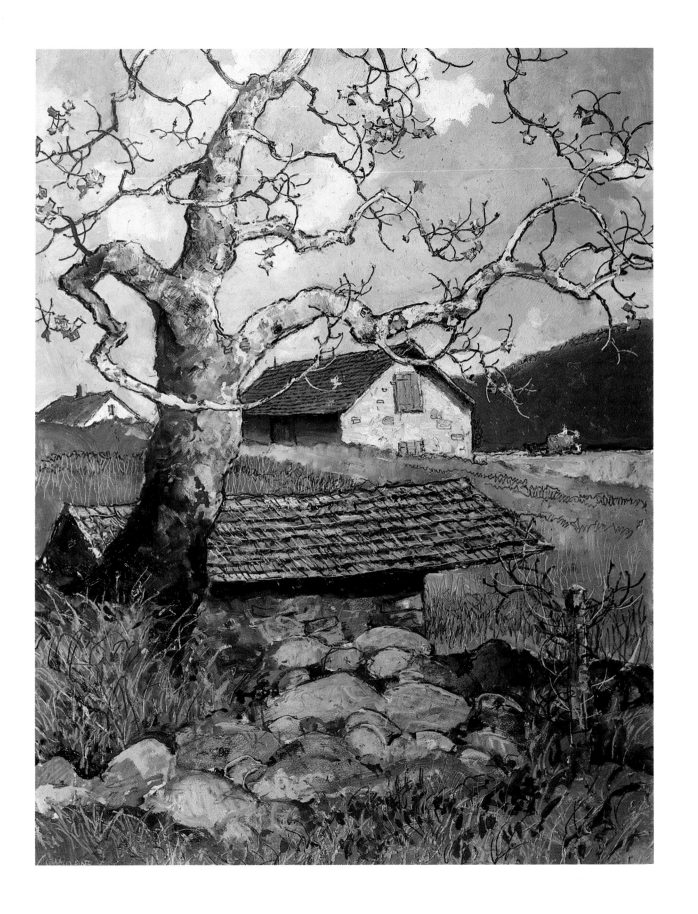

March Sunset

This painting was inspired by an ancient saltbox dwelling about a mile from my studio in Warren, Connecticut. Now restored by a New York City art gallery owner, it was once occupied by a crusty old New England lady who, during winter months, lived *inside* with her horse! The horse was allowed in the kitchen where it would rest in front of the huge fireplace and join in creating the only household heat. One winter the lady was found in her chair before the hearth, frozen. The horse was destroyed a few days later, and both were buried nearby.

The black locust trees that stand in the foreground reflect the feeling of the scene; they look dead or dying even during midsummer, but in March their leafless limbs seem to writhe in anguish. It is a season of desolation, cold rain, and melting snow. But the light in the window suggests a haven from the outside world where the comforting heat of burning wood makes life more bearable.

I have always tried to recreate a mood rather than to paint a scene. This portrayal of a March sunset sets the stage for many a melancholy moment that I have experienced.

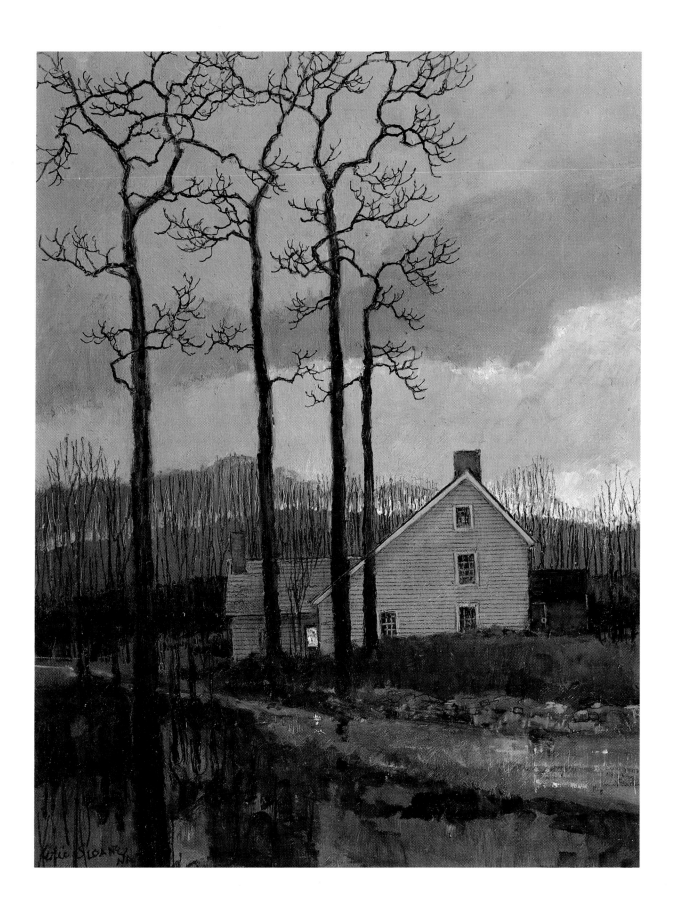

Amish Barn Door

Whether it be an invitation to enter or the protection of a locked entrance, doors have always been a symbol of great meaning to me. This Pennsylvania barn door of thick cedar planks with its ornate hood or "penthouse" is typical of the earliest stone barns. The Germans called these door hoods "penthouses," and to this day I haven't learned why. There were often hooks suspended from beneath these hoods, for hanging farm implements temporarily out of the rain.

These heavy barn doors were often removed completely during summer, leaving the barn interior open to weather, so I presume such practice made the door hood necessary for keeping out rain.

The two-piece door is still known as a "Dutch door" because New Yorkers used to refer to Germans as Dutchmen, but the design was German in origin, planned to ventilate homes during summer but keep animals from entering.

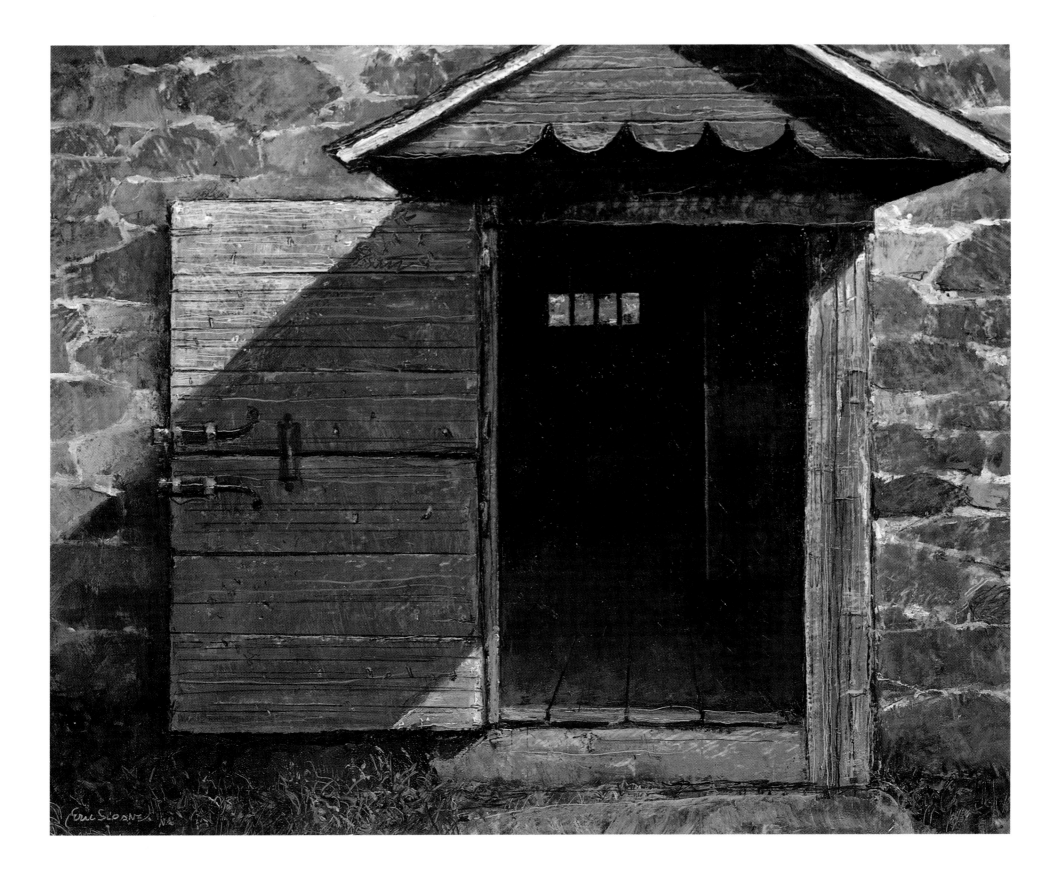

Winter Morning

With stratus cloud angle, horizon line, land line, and stone fence line, this painting is effective mostly because of the four simple angles that invite constant scanning. It is a composition of four shallow triangular shapes, and the central barn is such an arresting intrusion that it ties the triangles together and offers a center of interest.

The lace effect of the distant trees on the horizon was produced by the points of a razor blade, and the texture of rocks was made with the flat surface of the same blade. Unorthodox, but effective.

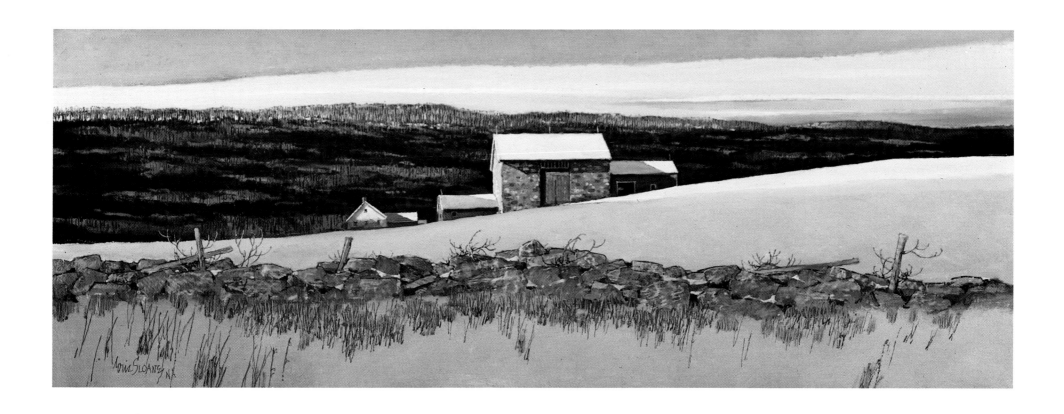

Hill Farm Barn

Maine architecture seldom sports elaborateness either in design or color. The farm buildings are pure stone and wood as if having grown from the ground. This simple building of pine siding that has been weathered to a pleasing gray is the recollection of a late summer jaunt to collect material for my book *An Age of Barns*. Most Maine farmsteads are of continuous architecture, with various buildings and sheds attached one to the other, but this barn stood away from the farm dwelling, high on a hill and worthy of a pencil sketch, which I recollected in oils.

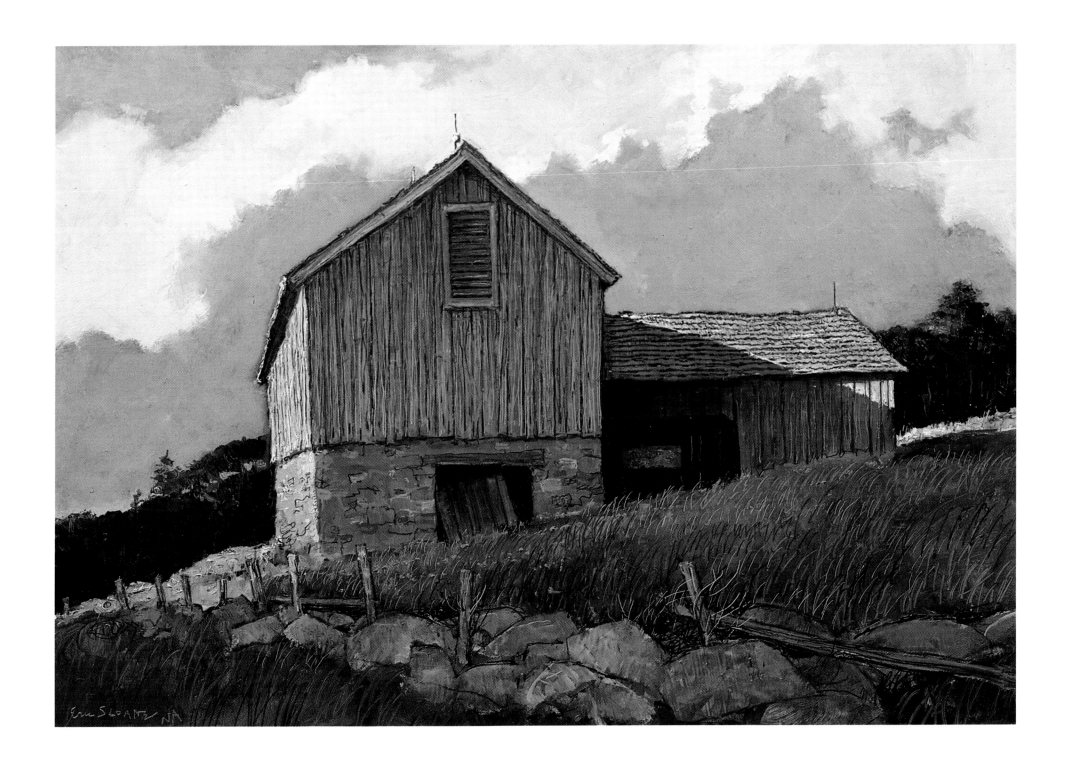

Sun Shaft-East Mesa

The Anasazi culture of Arizona and New Mexico always had a feeling of reverence for the land and the sky. The people lived within the womb of Mother Earth (rocks and adobe) and praised the spirit of Father Sky (the clouds and sky that afforded water and sunlight for existence).

This ancient structure atop a protective mesa (table mountain) symbolizes the ancient culture even more profoundly (in my mind) than the white man's religious interpretation of Heaven and the Holy Spirit.

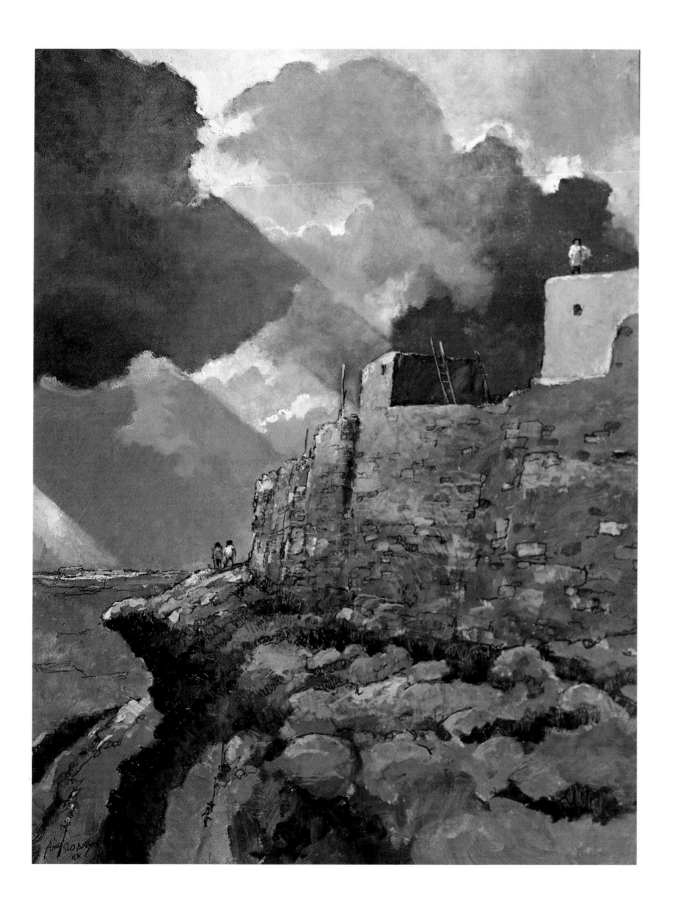

Closed for the Winter

The triangular hooded wagon-shed as shown here (called a "bevelly jog") was usually designed for wood construction, and when I discovered this one made of stone, I decided it was worth recording. Of course it was in Pennsylvania, where permanency was the prime architectural rule.

The stick against the barn door was less a way of locking than a farm symbol of "closed for the winter" or "please keep out."

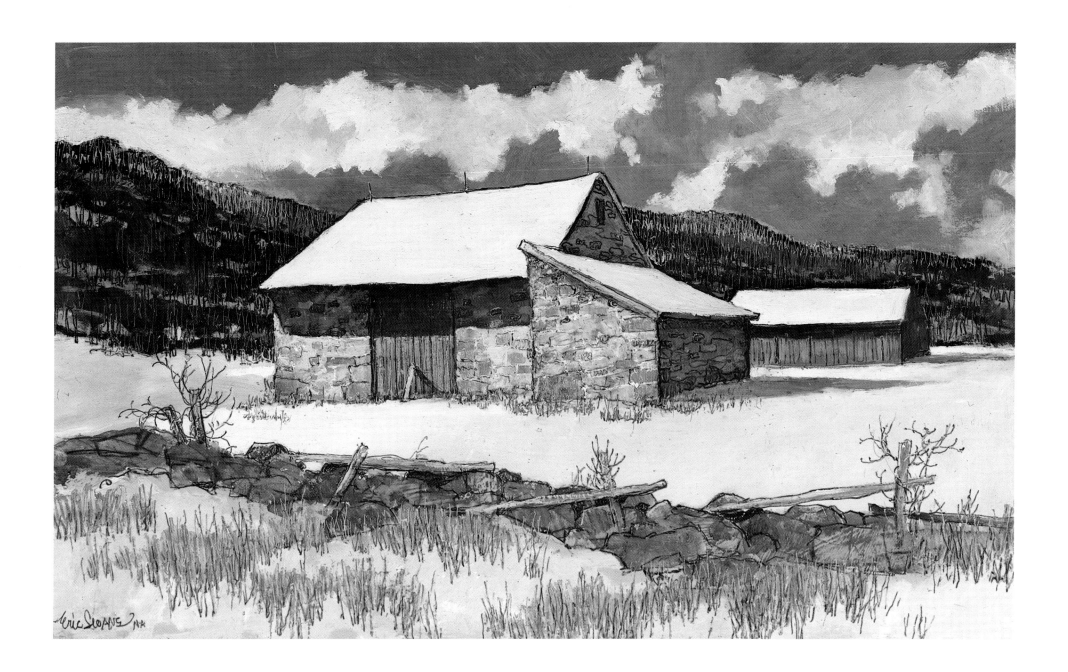

Sunset Flight

The word *landscape* is from the Dutch, meaning "the condition of land." I find it odd that the dictionary has neglected the skyscape for sky changes so rapidly and commands the entire mood of the land below. Most landscape paintings have more sky than land and the same may be said of seascapes; I reminded my friend William Morris who edited *The American Heritage Dictionary* and hope the next edition contains my word. I call it "my word" for I've spent over half a century as a skyscape and cloudscape painter without having heard the term used to describe what I've been doing.

Nature specializes in beauty, while man specializes in ugliness. We may defile the land; yet, if left alone long enough, nature will take over and cover the scars of mankind. But the sky remains the most untouched portion of the universe and to me, the most beautiful, worthy as a life study for any painter or poet.

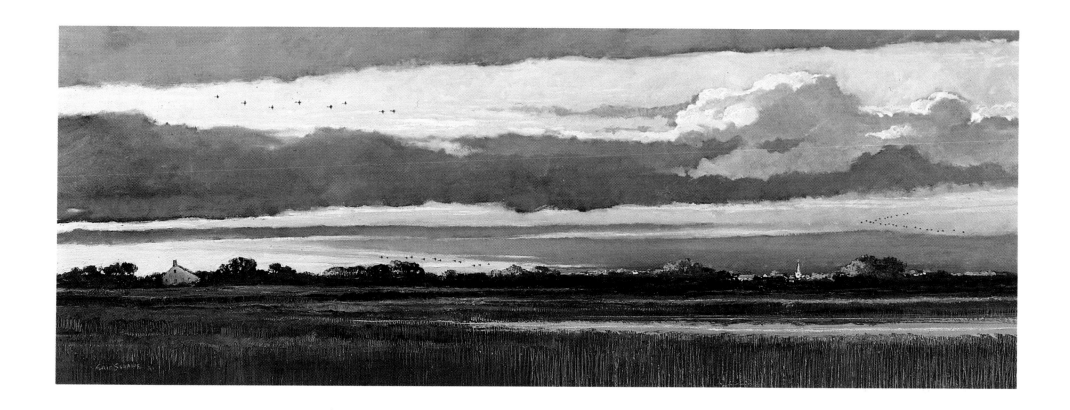

New England Autumn

Once upon a time I regarded covered bridges as being typical Americana. Indeed I was not alone for there are still organizations of buffs, hobbyists who travel the United States with camera recording the old wooden structures that seem to reflect the history of our nation. Then I learned about the earlier covered bridges of Europe and saw their superior construction. After having written books about the "American covered bridge heritage," I felt I was misinformed or at least that I had fallen for the mistake of overestimating. After all, most "American things" actually orginated elsewhere: hot dogs started in Holland, apple pie began in Germany, the automobile and airplane weren't American ideas and the first covered bridge was in Switzerland. It was disheartening.

Then after some reflection, I realized that America itself wasn't a "first" or even a *thing*: America was a *spirit*, and what I had really been writing about and painting was the American spirit. The thousand or so paintings I had done of American covered bridges were not outstanding examples of architecture, but they *were* reflections of the pioneer spirit. And spirit is more important than architecture. The realization made me feel better although I shall probably never paint another covered bridge.

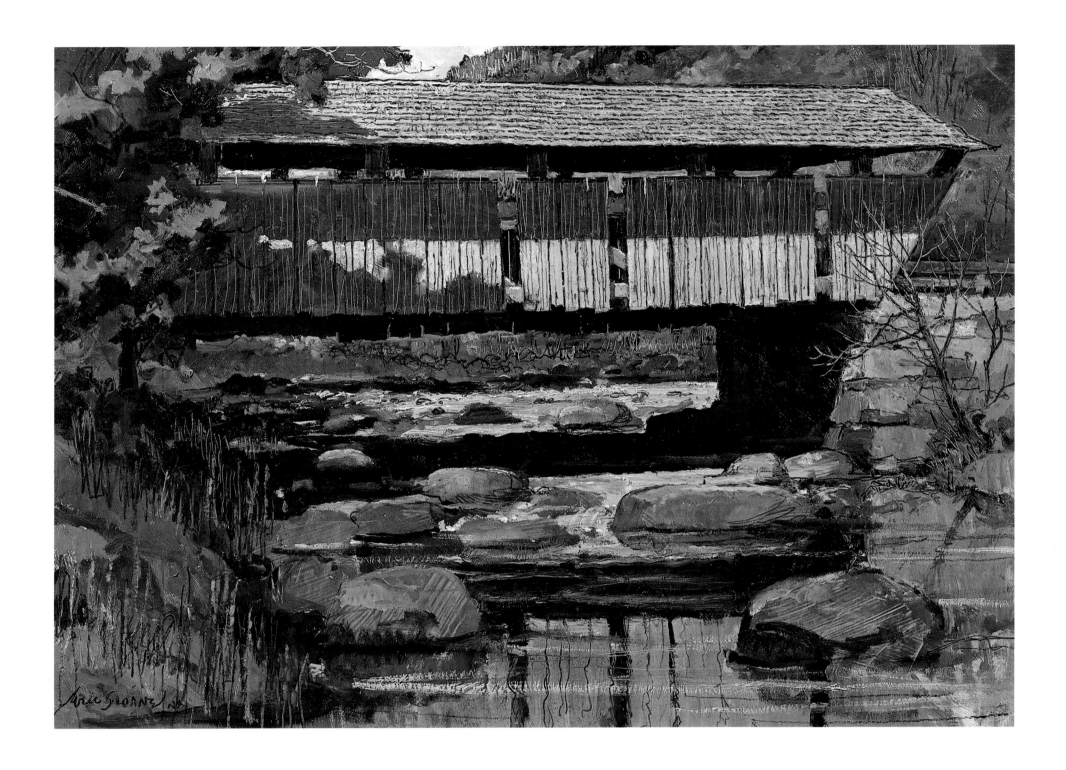

New England Red

I've always said I like any color as long as it is red. Perhaps that is one reason why I favor New England, where the red barn seems to have originated, and where during fall, the landscape seems to burst into a blaze of scarlet and brown.

Several decades ago in Warren, Connecticut, I originated an annual event to raise money for the volunteer fire department. It was a small party on my own lawn, but it evolved into a gigantic New England Fall Festival where many people come to view the spectacular colors of the countryside. After some research, we decided on a date when New England's trees might sport their richest coloring and that date was October the tenth. So on each Saturday closest to October the tenth, we pay homage to Nature and of course to the volunteer firemen.

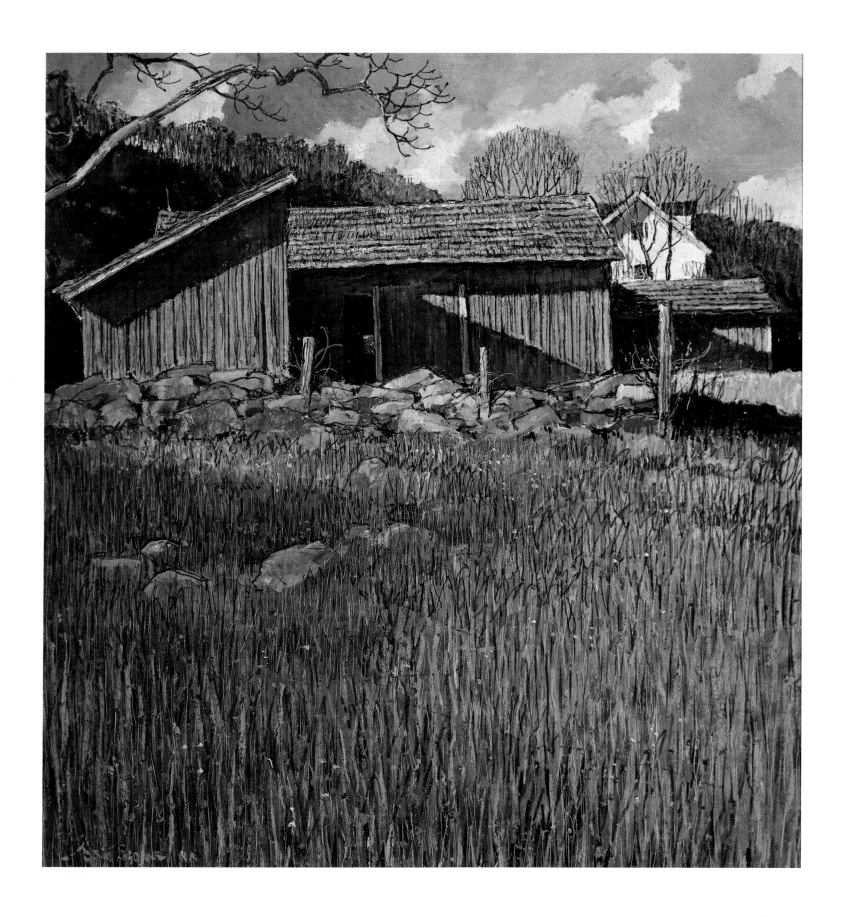

Heading South

The grayness of this winter afternoon matches the grayness of the unpainted barnwood and the old shingles. Few farm buildings escaped the fad of being painted; and fad it was, for the old, first-growth wood lasted better without being painted than it did with many coats of paint. The paint companies did a good job of selling nineteenth-century farmers their wares. Today the old unpainted gray pine barn siding has a patina and structure that brings a price per square foot that would have shocked the old-time builders.

This painting was done entirely from recollection, a remembrance of a wedge of geese flying south, a rickety frame of deserted farm buildings ready to fall and become part of the landscape, but mostly the grayness of a February day.

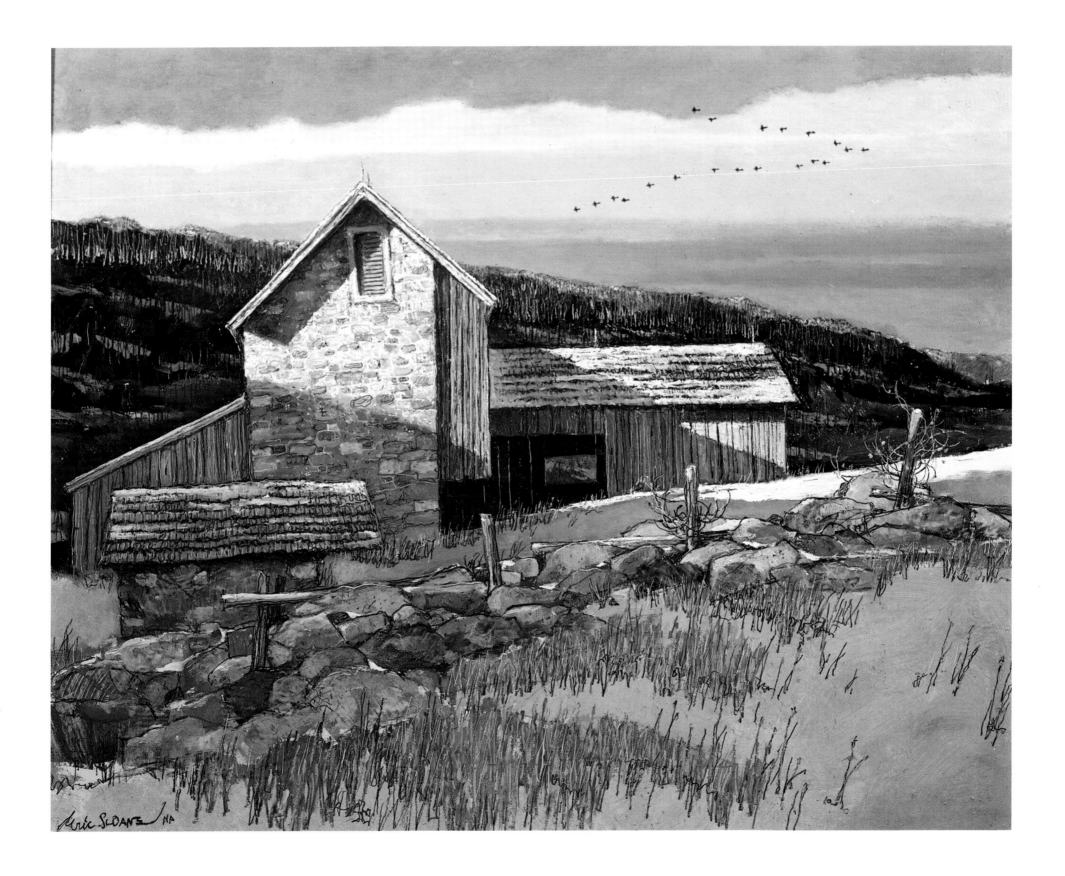

Spring Sky

Like shafts of sunlight streaming in the shadows of a great cathedral room, sunshine seen among storm clouds produces dramatic patterns in the panorama of sky. The effect is usually referred to as "the sun drawing water" but as all sunlight draws water (evaporates water content) the visible shafts of shadow are really places where the sun is *not* drawing water.

The introduction of birds in flight is not an art subject in itself but only a comparison object to demonstrate the immensity of clouds and the vastness of space.

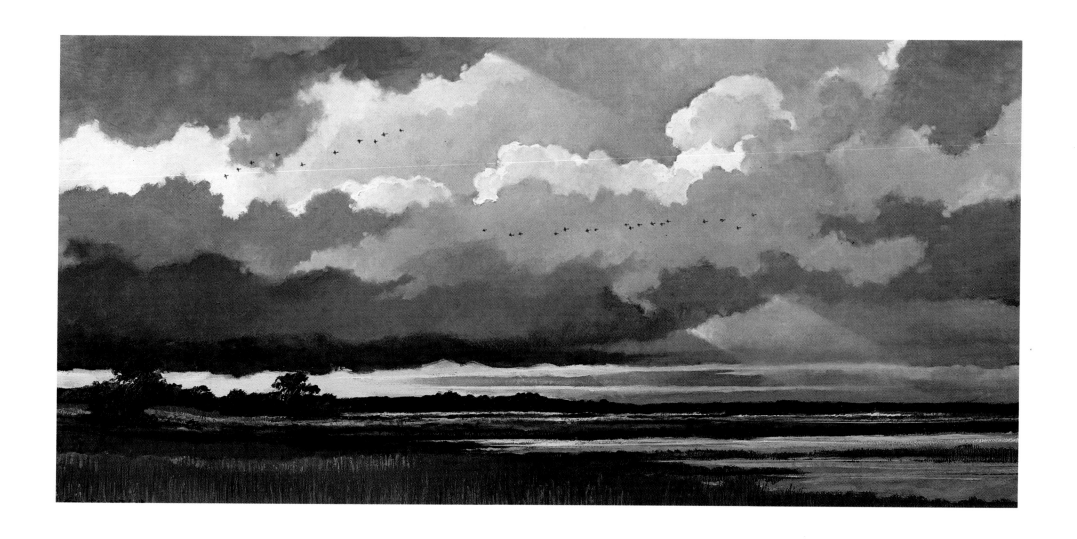

Over the Top

I have always thought that the best way to learn a subject was to write a book about it. At least it worked that way for me. So in 1948 when I had decided to make painting the sky a life work, I did a book called *Skies and the Artist*. It wasn't a project for making money but it accomplished its purpose which was to make me realize the anatomy of weather and the construction of clouds. I became aware of a sky perspective that exists just as there is a land perspective. I discovered there is a color perspective in the sky just as there is in land (but it is reversed!). In land, distance becomes bluish, middle ground has a yellow aura while red suggests closeness (distant mountains, for example, become blue). But the "close" or overhead sky is blue and the distant sky horizon is reddish (opposite from land color perspective). The introduction of perspective coloring may be subtle and unnoticeable, but the effect becomes three-dimensional.

Skies and the Artist is now a rare booklet (I have only one copy) but I believe it was the only work written for painters about the subject of sky. The painter it was written for was me.

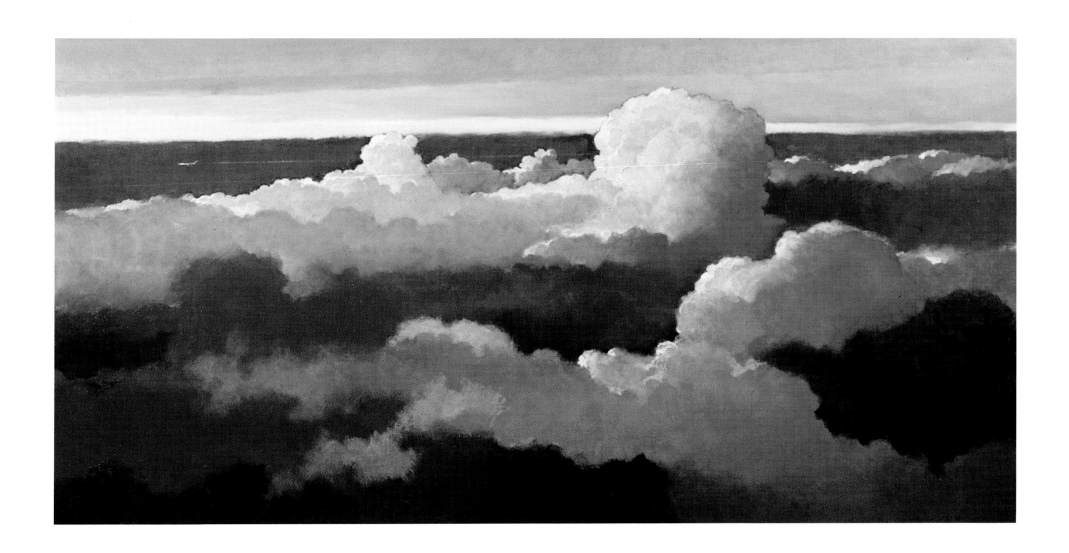

Straw Harvest

This scene, not far from my New England studio, depicts what the local farmers call "straw harvest." A last crop of hay, mostly weeds and stubble grass used largely as barn straw, marks the coming of fall.

I find such a composition less a picture than a harmony of shapes. Broad triangles of light and shadow as the autumn sun sets earlier and shadows deepen toward the end of day create zig zag shapes that invite the eye to scan the landscape back and forth and enjoy the panorama.

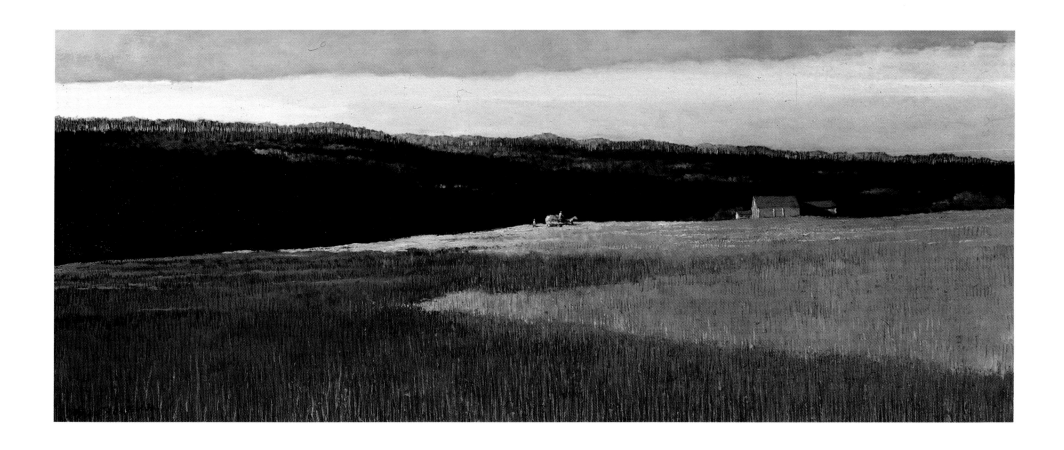

Adobe Facade

A word of Arab origin, *adobe* means "earth from which unburnt bricks are made." Technically speaking, it is a balanced mixture of clay and sand, enough sand to keep the dried mixture from cracking, with bits of straw to bind it together. The result is a mosaic of earthy texture worthy of any painter's efforts to simulate. I've found that scraping paint away with a flattened razor blade produces an effect that I myself could not do, creating an adobe effect miraculously.

I find it interesting that new codes of building have made the use of adobe bricks unlawful, stating that "adobe is not a lasting material." The group of Indian rooms shown in my painting were quite the same when Coronado found them in 1548. Except for an occasional plastering, adobe has proven itself to be the most lasting of all American architecture.

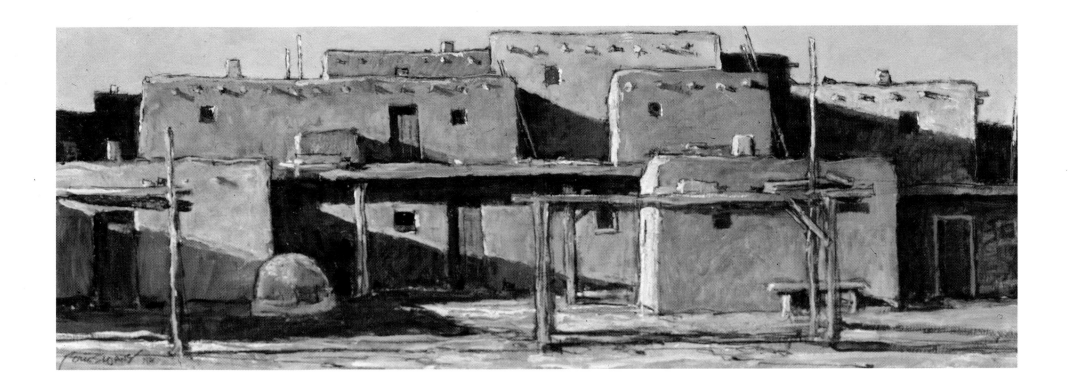

PRINTED IN ITALY
BY
EDITOR ⓔ